中国首批世界自然遗产
World National Heritage

全国首批世界地质公园
The First Batch Of World Geoparks In China

世界"张家界地貌"命名地
World naming place of Zhangjiajie landform

中国第一个国家森林公园
China's First National Forest Park

国家首批AAAAA级旅游景区
The First Batch Of AAAAA Tourist Attractions In China

全国文明风景旅游区
National Civilized Scenic Spots

U0101180

画说

张家界

PICTURING
ZHANGJIAJIE

张家界市文化旅游广电体育局／编

湖南地图出版社
HUNAN MAP PUBLISHING HOUSE

·长沙·

图书在版编目（CIP）数据

画说张家界 / 张家界市文化旅游广电体育局编 . -- 长沙：湖南地图
出版社，2022.8

ISBN 978-7-5530-1091-5

Ⅰ . ①画… Ⅱ . ①张… Ⅲ . ①摄影集 – 中国 – 现代②张家界 – 摄影
集 Ⅳ . ① J421

中国版本图书馆 CIP 数据核字 (2022) 第 146867 号

画说张家界

HUASHUO ZHANGJIAJIE

编　　　者：张家界市文化旅游广电体育局

责任编辑：邓吉芳

责任校对：刘海英

出版发行：湖南地图出版社

地　　　址：长沙市天心区芙蓉南路四段 158 号

邮　　　编：410118

发行电话：0731-85585163

技术支持：湖南江陶设计有限公司

装帧设计：闰江文化

印　　　刷：湖南地图出版社

开　　　本：787 毫米 ×1092 毫米 1/16

印　　　张：11

字　　　数：270 千

印　　　数：1—5000

版　　　次：2022 年 8 月第 1 版

印　　　次：2022 年 8 月第 1 次印刷

书　　　号：ISBN 978-7-5530-1091-5

定　　　价：58.00 元

张家界市在中国的位置

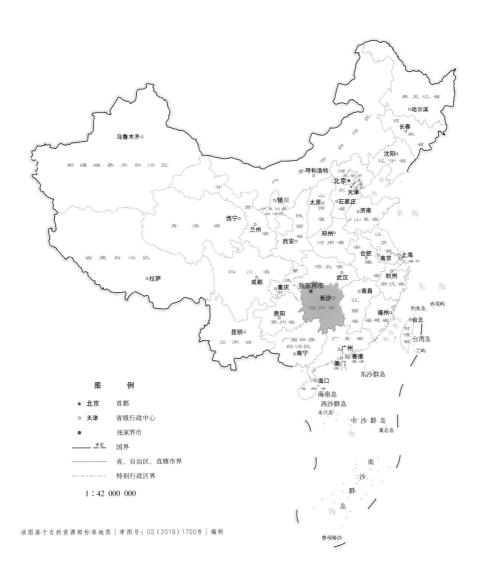

图　例

★ 北京　首都

◦ 天津　省级行政中心

● 　　　张家界市

——— 国界

——— 省、自治区、直辖市界

--------- 特别行政区界

1：42 000 000

该图基于自然资源部标准地图［审图号：GS（2019）1700号］编制

请柬

一份来自张家界的邀约

我有奇峰三千，像三千根青翠的竹笋

已育了三亿八千万年，纯天然

我有秀水八百，像八百坛醇香的好酒

已酿了三亿八千万年，味正浓

我有黄石寨，可安营、可吟风、可弄月

我有天子山，可登高、可抒怀、可望远

我有大峡谷玻璃桥，可渡一辈子的情和缘

我有天门山天地之门，洞开、可览风云变幻

我有茅岩河九曲十八湾，可让你漂一次迷一生

我有古庸国留下的石桌，安放在崇山之巅

我有宽阔的客厅两万亩，迎候在七星山顶

我有三下锅，灶火正旺，让你每天像过年

我有桑植白茶，煮风煮雨，煮着一壶滚热的激情

我有月做的酒杯千万只，等着你在澧水的岸边

我有大景若干，小景上千

大景即大菜，小景即小碟

我摆的是山水与文化的盛宴，开的是流水席

白天不散，晚上不断

已经开了三亿八千万年，还要再开三亿八千万年

这样的盛宴怎能没有你，这样的盛宴你怎能不来

呵呵，你来就逮，你来就上菜，你来就开怀

请柬就此送达，我们约定：

联络暗号——因为风光因为爱

联络地点——两县两区 9533 平方公里的每一寸土地

我们再约定——不见不散，不醉不罢休，一醉千年友

敬邀者

张家界

INVITATION

An Invitation from Zhangjiajie

Here stand three thousand magic peaks, like three thousand verdant bamboo shoots.
They have been nourished for 380 million years, purely natural.
Here exist eight hundred rivers and lakes, like eight hundred jars of fine wine.
They have been brewed for 380 million years, tasted mellow.
Here is Huangshi village, where you can make your camp, recite poems, and enjoy the beautiful moon night.
Here is Tianzi Mountain, where you can climb high, express your feelings, and look far into the distance.
Here is the glass bridge on the Grand Canyon, where you can ferry a lifetime of your love and fate.
Here is Tianmen Mountain, Gate of Heaven and Earth, where you can enjoy its changing wind and cloud when it's open.
Here is Maoyan River with nine bends and eighteen bays, where you challenge the rafting once and will love it forever.
Here is the rock table on the top of the Chong Mountain, handed down from the ancient Guyong State.
Here is a 20-thousand-mu lobby, like wide plain, waiting for you on top of the Seven-star Mountain.
Here is Sanxia Pot boiling on the fire, making your daily life as spending Spring Festival.
Here is the white tea planted in the Sangzhi County, boiling a pot of hot passion with wind and rain.
Here are thousands of wine cups made from moon, waiting for you by the Li River.
Here are several famous sights and many small scenic spots.
The famous sights are like the big dishes, and the small scenic spots are like delicious snacks.
I offer you a banquet of magnificent scenery and splendid culture, always at your service.
The banquet is ongoing all day and night.
The banquet has been for 380 million years and it will last for another 380 million years.
How can such a feast be without you? How can you not come to such a feast?
Hah! We will be together on your arrival.
We will serve you delicious food on your arrival.
And we will have a happy and joyful time on your arrival.
The invitation has been sent to you, and let us make an appointment.
Our contact sign is "For the scenery and for the love! "
Our contact location is every inch of land of 9533 square kilometers in two counties and two districts
Let us make the appointment again.
Be there or be square.
Let us drink luscious wine to our hearts' content.
Let us be friends for a thousand years.

Sincerely Inviter

Zhangjiajie

张家界简介

仙境张家界，峰迷全世界。

张家界是山水经典，诗画之源，画幅 9533 平方公里。画中澧水蜿蜒，33 个民族逐水而徙，依山而居，创造了人类的世外桃源，也绘就了当代的旅游盛景。中国首批世界自然遗产、全国首批世界地质公园、世界"张家界地貌"命名地、中国第一个国家森林公园、国家首批 AAAAA 级旅游景区、全国文明风景旅游区……是他们给这幅画卷颁授的勋章。

三千奇峰，八百秀水，是这幅画卷鬼斧神工的构图。武陵源青山野立，奇石险峻；天门山巍峨耸立，天门洞开；茅岩河秀水欢腾，千帆逐浪；大峡谷清风送爽，云天飞渡。古村古镇，小巧静雅，乡村四野，安放心灵。300 多个景区景点浩如烟海，33 个国家 A 级景区灿若星河，其中 2 个 AAAAA 级景区比肩而立，11 个 AAAA 级景区遍布全域。

红旗漫卷，人文荟萃，是这幅画卷绚烂壮丽的色彩。汉族、土家族、白族、苗族等民族在这里繁衍生息，留存了十大类 818 项非物质文化遗产。桑植民歌、桑植仗鼓舞、张家界阳戏等国家级非物质文化遗产项目熠熠生辉，每年一次的元

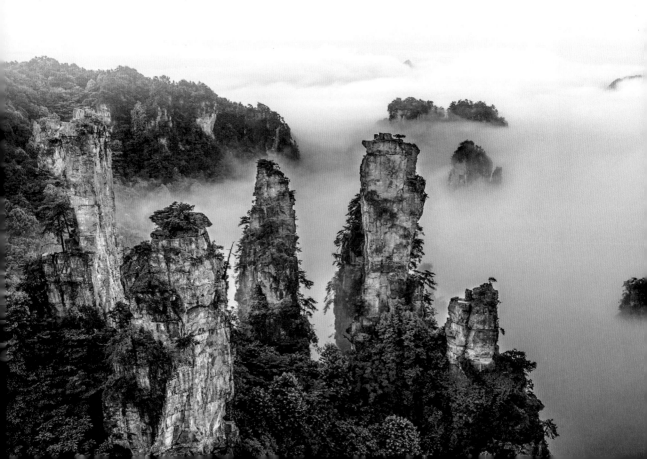

宵灯会吸引 30 多万人一起狂欢，魅力湘西、天门狐仙被列为国家文化产业示范基地。全市 4 个区县均为革命老区县，这里是贺龙元帅故里、中国工农红军第二方面军长征出发地、湘鄂川黔革命根据地中心区域，任弼时、贺龙、关向应、萧克、王震等老一辈革命家曾在此浴血奋战，给这片土地浇铸了鲜红的气质。

多面山城，自在趣玩，是这幅画卷扣人心弦的细节。漫居山谷治愈漂泊的心灵，流云飞瀑蕴藏自然的奥秘，乡村四野怀抱任你撒野，房车露营体验"野居"新奇，峰林骑行点燃青春脉动，喷射快艇带你逐浪天涯，飞拉达、高空蹦极释放你的超能，冰雪世界打破季节的限定……打开数不尽的"盲盒"，就能感受不一样的心动。

一路畅行，山水悠然，是这幅画卷细致入微的质感。航空、高速铁路、高速公路，构筑起高效便捷的立体交通，拉近了张家界与世界的距离；全市有酒店、民宿等近 2000 家，其中星级酒店 11 家（五星级 3 家），星级民宿 30 多家，可奢华、可小资、可简约；山里的美食顷刻俘获人心，放任味蕾享受舌尖的治愈；自然造就的山货土产，带着阳光的味道，和您一起感受山水生态沉淀的质感。

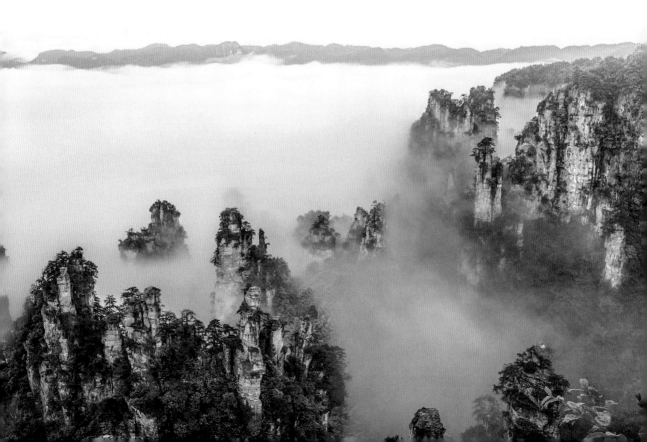

How fascinating a wonderland Zhangjiajie is for all over the world!

Zhangjiajie is a classic of landscape, the source of poetry and painting, covering a territory of 9533 square kilometers. In it Li River winds and 33 ethnic minorities migrate by water and live by mountains, which has created a land of idyllic beauty and painted a contemporary grand view. It has been awarded with six medals: one of the first batch of World Natural Heritages in China, one of the first batch of World Geoparks in China, the named place of world "Zhangjiajie Landform", the first National Forest Park in China, one of the first batch of National AAAAA Level Tourist Attractions and National Civilized Scenic Spots.

Thousands of magic peaks and hundreds of miles of beautiful water compose a marvelous picture scroll, in which green mountains with strange and steep rocks stand in Wulingyuan, Tianmen Mountain towers, with its Tianmen Cave open. In addition, the water in Maoyan River flows brightly, with boats chasing waves on the river, and flying through Grand Canyon in a cloudy day is exciting, with fresh wind bringing coolness. The small ancient villages and towns, quiet and elegant, can make us relax our bodies and minds and feel at ease. There are more than 300 scenic areas and spots and 33 National A Level Tourist Attractions, among which 2 National AAAAA Level Tourist Attractions stand together, and 11 National AAAA Level Tourist Attractions exist all over Zhangjiajie.

The fluttering red flags and a gathering of talented people endow the Zhangjiajie picture with more imposing colors. The Han, Tujia, Bai, Miao and other ethnic groups thrive here and have left us ten main categories of 818 Intangible Cultural Heritages. Sangzhi Folk Songs, Sangzhi Battle-drum Dance, Zhangjiajie Yang Opera, and so on, shine brilliantly. The annual Lantern Festival attracts

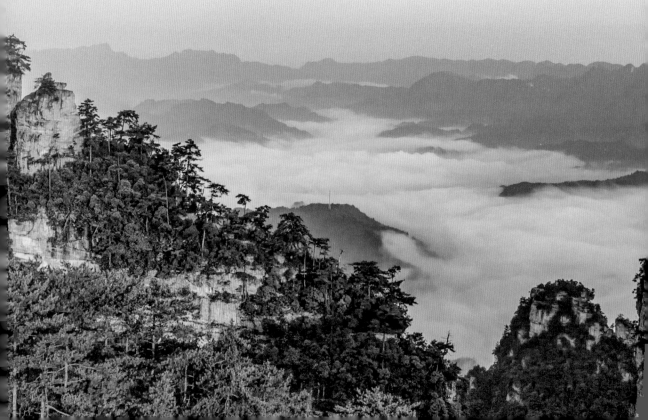

more than 300000 people to revel together. Charming Xiangxi and Tianmen Fox Fairy are listed as national cultural industry demonstration bases. The 4 districts and counties of Zhangjiajie are all old revolutionary bases, and there exits the hometown of Marshal He Long, the starting point of the Long March for the Second Front Army of the Chinese Workers' and Peasants' Red Army and the heartland of Hunan-Hubei-Sichuan-Guizhou Revolutionary Base. The land has been given more red genes because those old-generation revolutionists, Ren Bishi, He Long, Guan Xiangying, Xiao Ke and Wang Zhen, etc. fought a bloody war here.

The multiple features of the mountain city and the free and funny travel are fascinating details of the pictures. Living in the valley may heal the wandering mind. The flowing clouds and roaring-down waterfalls contain the mystery of nature. You can play and relax at ease in rural wilderness. RV camping makes you experience "wild" novelty. Peak forests cycling may activate youthful enthusiasm. The yacht will take you chase waves. Via Ferrata and high-altitude bungee jumping may release your superpowers. Ice and snow world breaks the limitation of the seasons. Opening countless "blind boxes", you can feel different heartbeats.

Convenient transportation and homey trip have added the fine quality to the picture. The aviation, high-speed railway and highway have built an efficient and convenient three-dimensional transportation and shortened the distance between Zhangjiajie and the world. Zhangjiajie has nearly 2000 hotels, homestay inns, etc. , among which there are 11 star-level hotels(3 five-star hotels), and more than 30 star-level homestays. They can be luxury, petty bourgeoisie and simple. The fine food here is so moreish that promptly we'll like it and we just want to enjoy it. The natural specialties with sunshine flavor always make us have endless aftertaste.

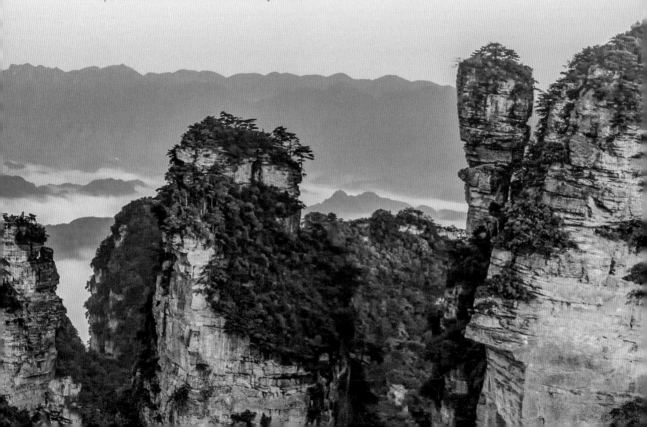

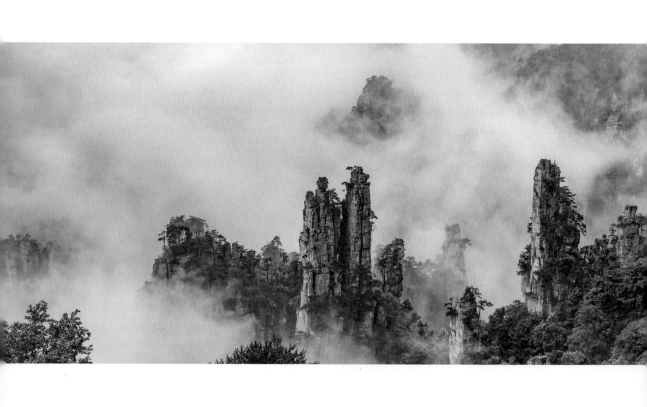

目录

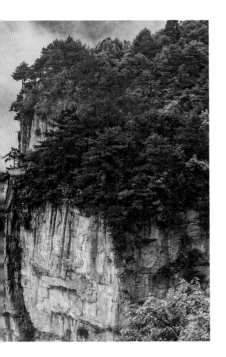

奇峰秀水
The Magic Peaks and Beautiful Water

目 录
CONTENTS

人文荟萃
Gathering of Talents

山水艺苑
Culture and Arts Show
076

山城趣游
Funny Tour in Mountain city

畅游心选
Enjoyable Tour to Scenic Spots

编后记
Postscript

山风如丝也如薰，轻抚峰峦间。
月华如水也如酒，静泻溪涧上。
掬一捧清辉，饮一口月光，
长醉于这无上美景。
伴着山林的低吟轻唱，
于朦胧缠绵的树影里随风起舞，
恣意享受自然的曼妙。

The mountain wind, as silk and as smoke,
wanders among the peaks.
The moon light, as water and as wine, shines
softly on the brooks.
Hold a bit of moonlight in hands, and enjoy it.
Being intoxicated in the extreme beauty.
Followed by whispering singing from the
forest.
Dance with the wind in hazy tree shadow.
Relax and enjoy the beauty of nature.

奇峰秀水

The Magic Peaks
and Beautiful Water

武陵源景区
Wulingyuan Scenic Spot

国家 AAAAA 级旅游景区
National AAAAA Level Tourist Attraction

位于张家界市武陵源区
Located in Wulingyuan District, Zhangjiajie City

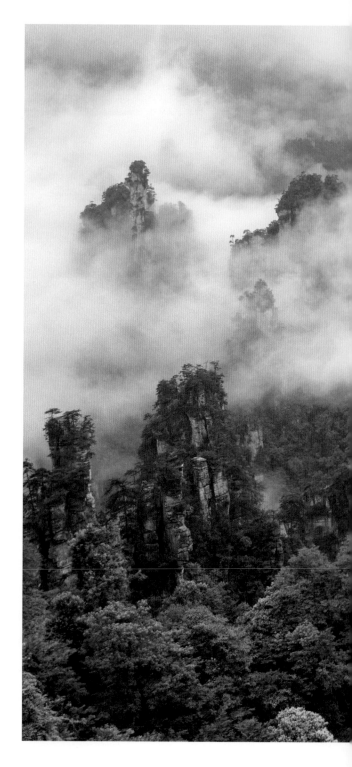

武陵源，从跨越亿年的时光长河里拥着浪花，奔腾而至；从充满灵性与感情的画面里带着呢喃，袅娜而来。沧海桑田，历经数次地壳升降和沉积演化，海陆交替、内外合力，最终形成独特的"张家界地貌"。境内石峰林立，如笋生，似剑立；秀水蜿蜒，层林叠翠，鸟兽成群；集山、水、洞、瀑、湖等自然景观之大成，融独特地貌、大森林及生物多样性、多民族风情等多种旅游资源于一体。三千奇峰为笔，八百秀水为墨，在长空大地里为您描绘一幅人间醉美之画。

Wulingyuan, rushing to us like waves over several hundred million years of time, has gracefully come to us whispering from the picture full of spiritual and emotional feelings. Time brings great changes to the world. Several crustal movements, sedimentation evolution, and Sea-land alternation have given birth to "Zhangjiajie landform". There are many peaks, like bamboo shoots or like swords. The beautiful water winds among the peaks covered in lush green vegetation and rich in animals. Zhangjiajie is a collection of mountains, water, caves, waterfalls, lakes and other natural landscapes, and a combination of unique landscapes, forests and biodiversity, different folk customs and other kinds of tourism resources. Zhangjiajie is an intoxicating beautiful picture on the earth painted by a master, thousands of magic mountains as his pens and hundreds of miles of beautiful water as his inks.

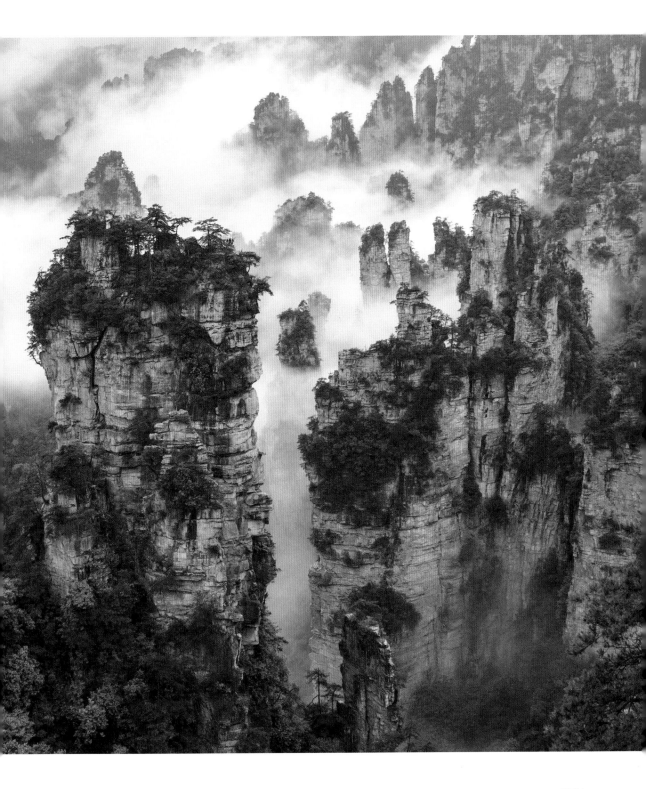

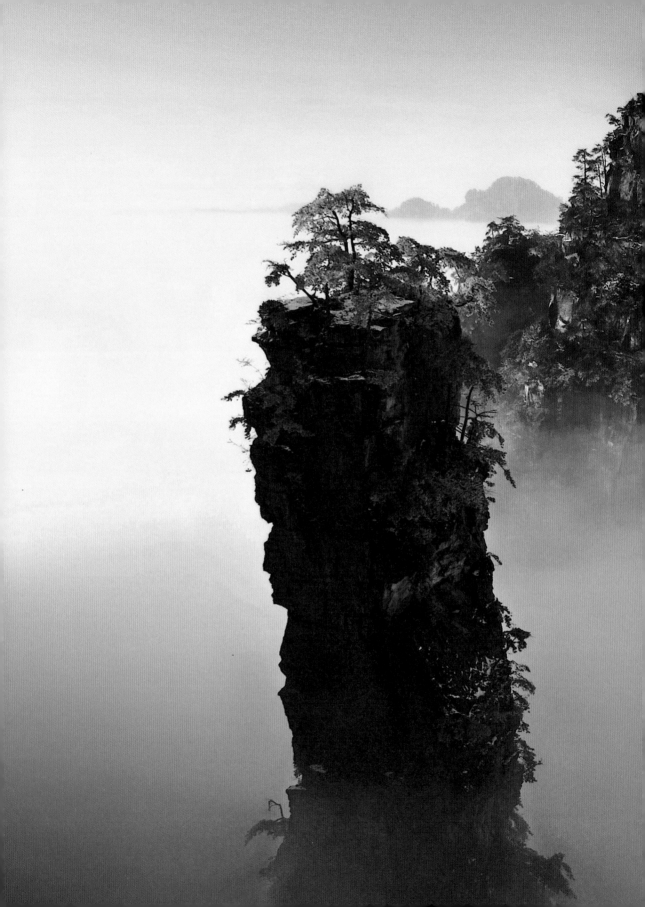

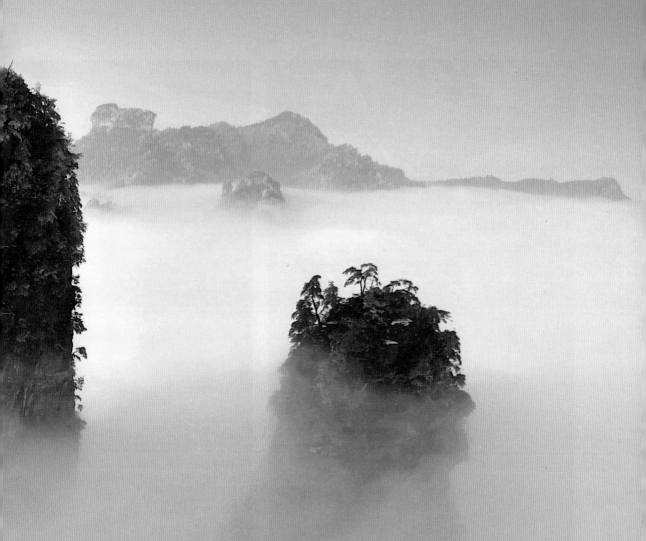

金鞭溪

Golden Rod Stream

世界上最美丽的峡谷之一
One of the most beautiful canyons
in the world

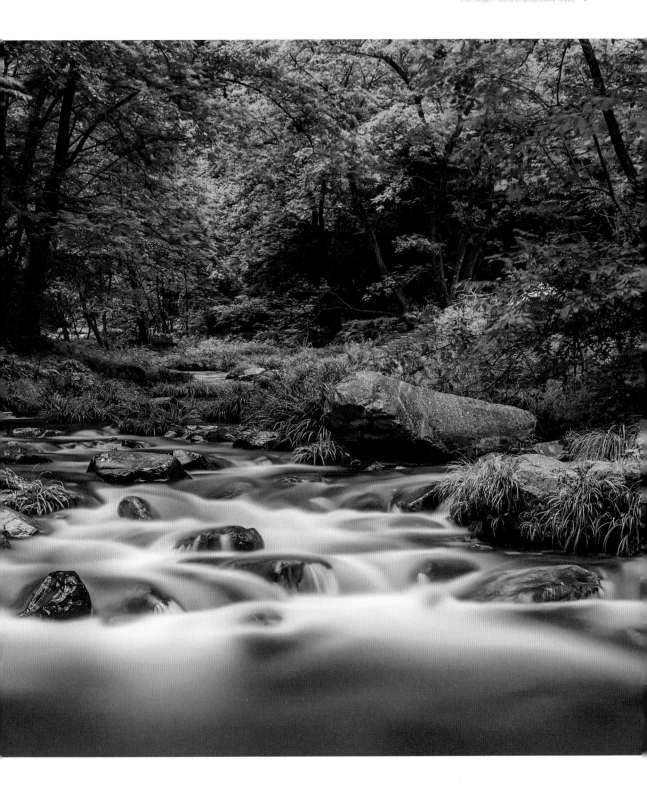

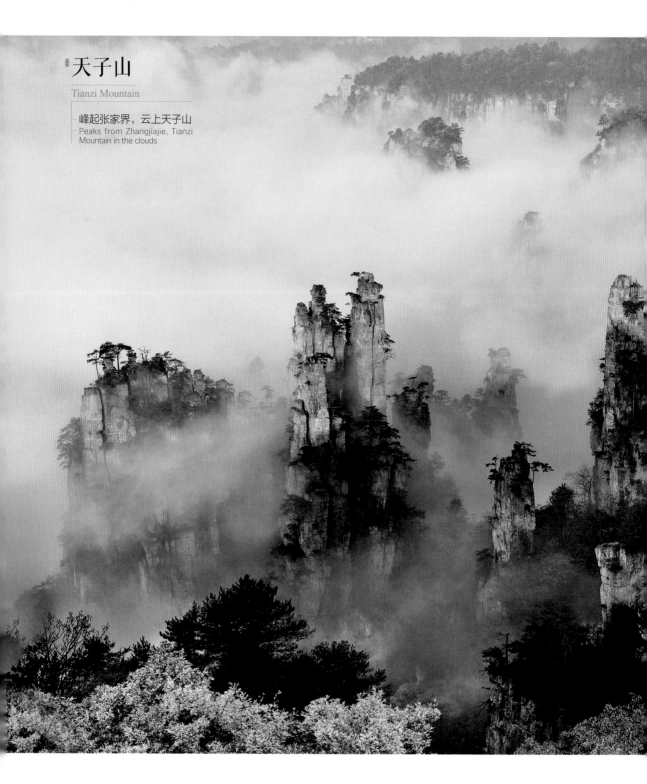

天子山

Tianzi Mountain

峰起张家界，云上天子山
Peaks from Zhangjiajie, Tianzi
Mountain in the clouds

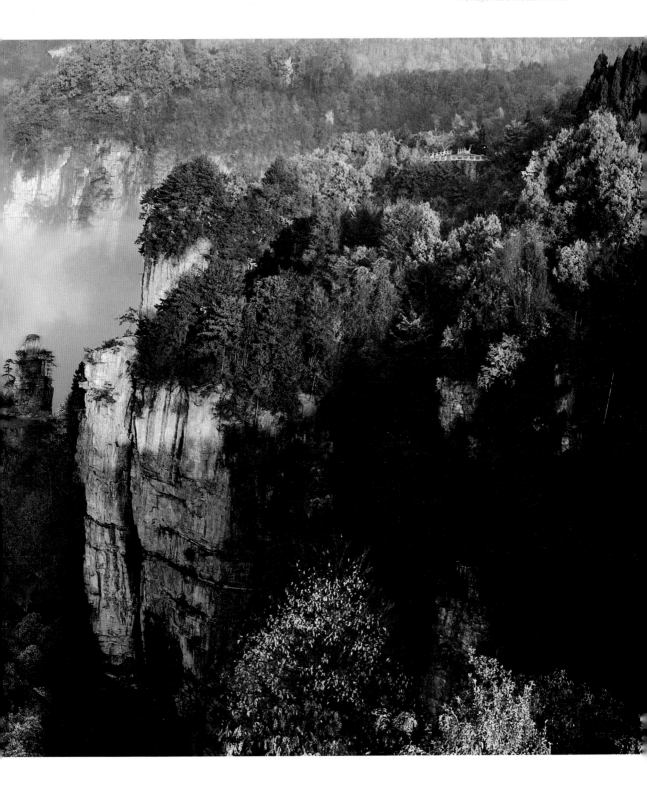

袁家界

Yuanjiajie

悬浮的外星世界
Suspending alien world

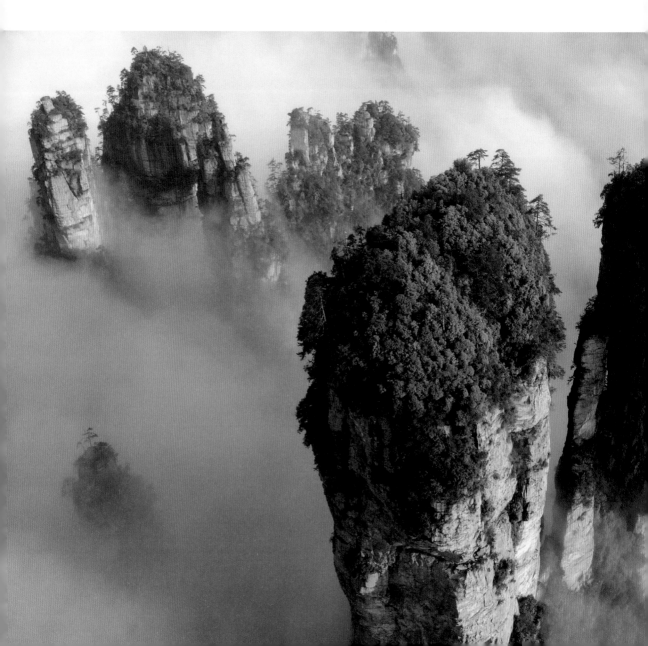

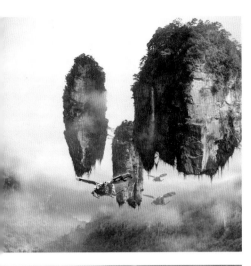

◀ 电影《阿凡达》画面
The Movie *Avatar*

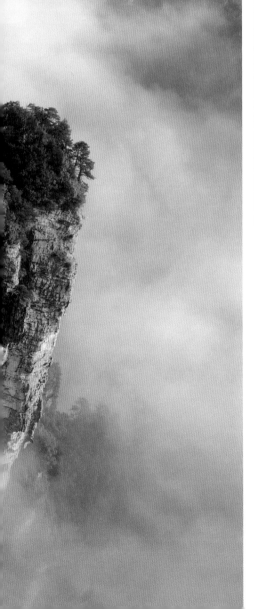

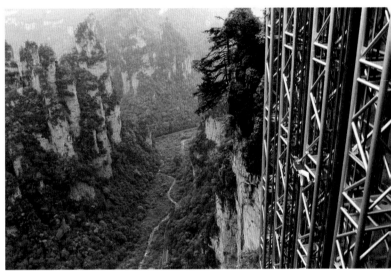

▲ 蜘蛛人攀爬百龙天梯
"Spider Man" Climbing Bailong Ladder

2013 年 5 月 18 日，张家界市武陵源风景区，法国著名"蜘蛛人"卡萨诺瓦成功挑战徒手攀爬世界第一梯百龙天梯，用时 68 分 26 秒。

On May 18, 2013, in Wulingyuan Scenic Area, Zhangjiajie City, France's famous "Spider man" Casanova successfully climbed the world's first ladder, Bailong Ladder, with his bare hands, taking 68 minutes and 26 seconds.

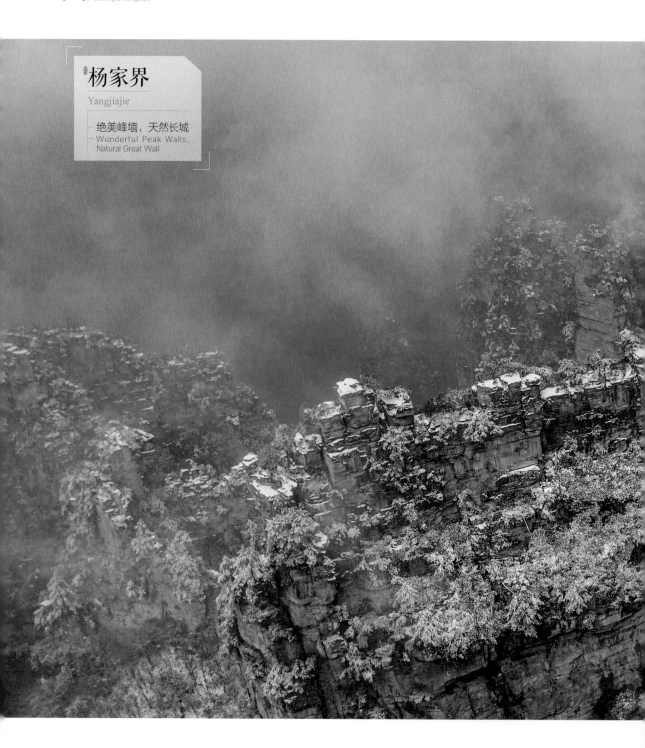

杨家界
Yangjiajie

绝美峰墙，天然长城
Wonderful Peak Walls,
Natural Great Wall

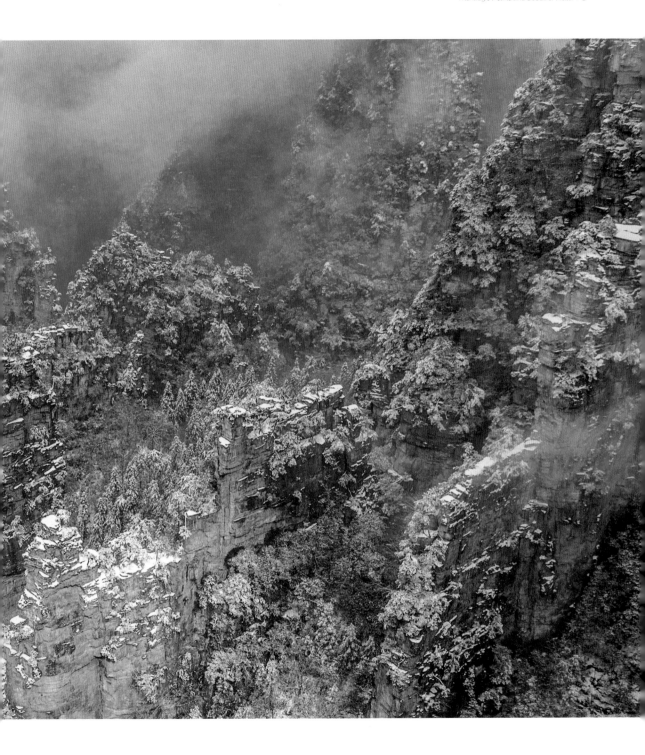

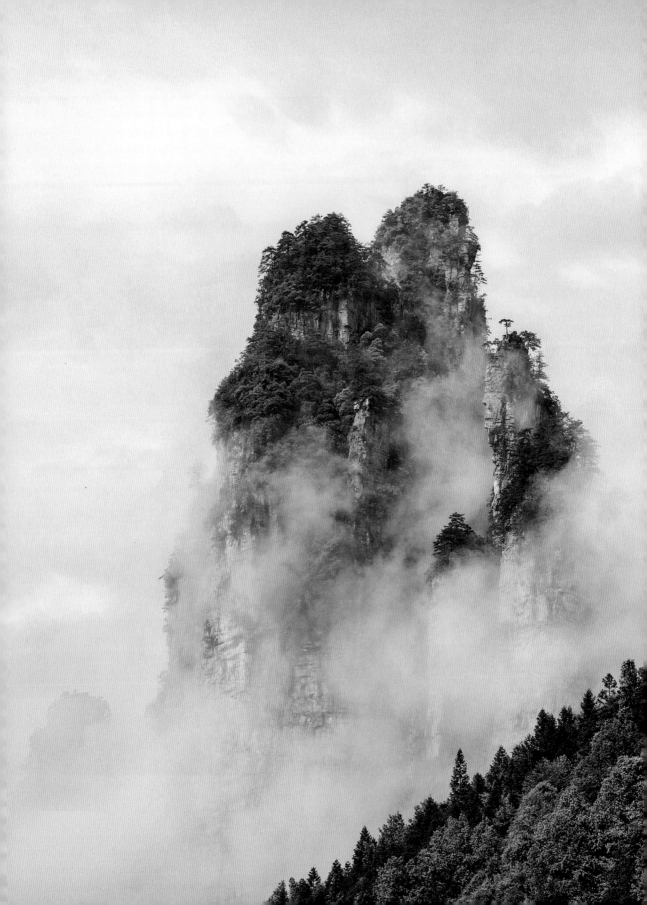

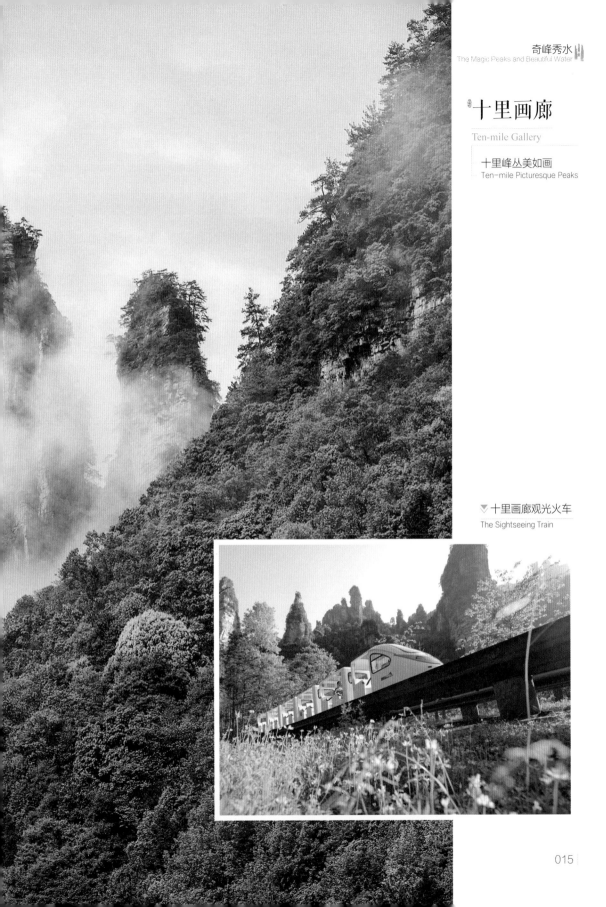

十里画廊
Ten-mile Gallery

十里峰丛美如画
Ten-mile Picturesque Peaks

▼ 十里画廊观光火车
The Sightseeing Train

水绕四门
Four Mingling Streams

水在山间流，人似水中游
Water flows between mountains,
as if men swim in water

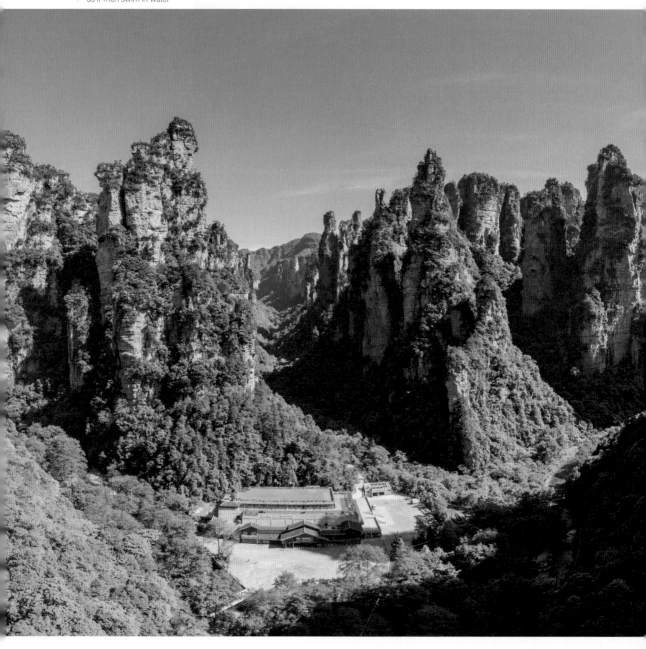

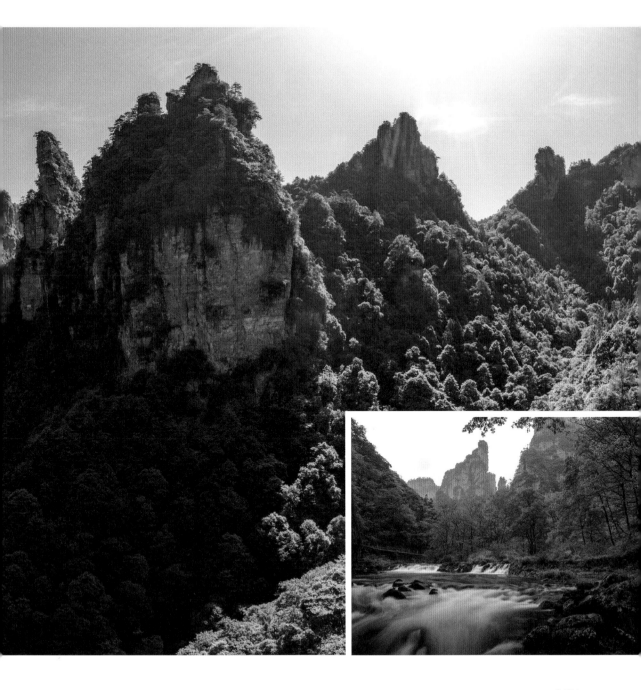

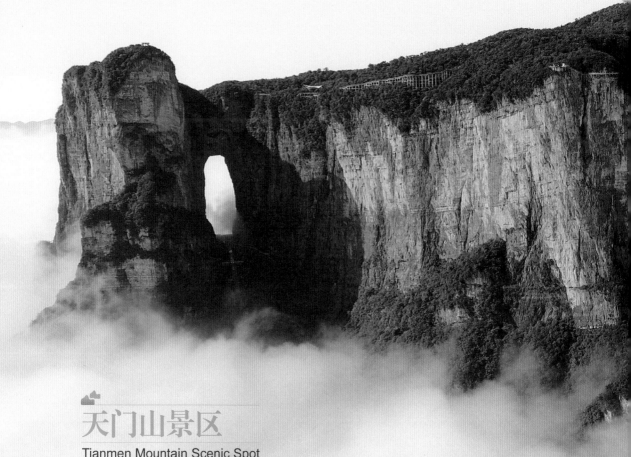

天门山景区
Tianmen Mountain Scenic Spot

￥ 国家 AAAAA 级旅游景区
National AAAAA Level Tourist Attraction

位于张家界市永定区官黎坪街道
Located in Guanliping Street, Yongding District, Zhangjiajie City

　　天门山因自然奇观天门洞而得名，千米绝壁上洞开如门，吞云吐雾，纳天地灵气。鬼谷显影、独角瑞兽等传说，为天门山增添了神秘气息。自然与人文在这里交织，历史与现代在这里碰撞。乘索道穿越群峰万壑，走玻璃栈道体验踏云快感，游天门山寺感受佛教洗礼。山顶四时景色不同，而乐亦无穷：春赏百花，夏看流霞，秋醉霜叶，冬眠冰雪。

　　1999 年飞机穿越天门洞，让天门山名扬天下。此后，越来越多的大型极限运动赛事和挑战活动选择在这里举行，天门山成为"极限运动圣地"。

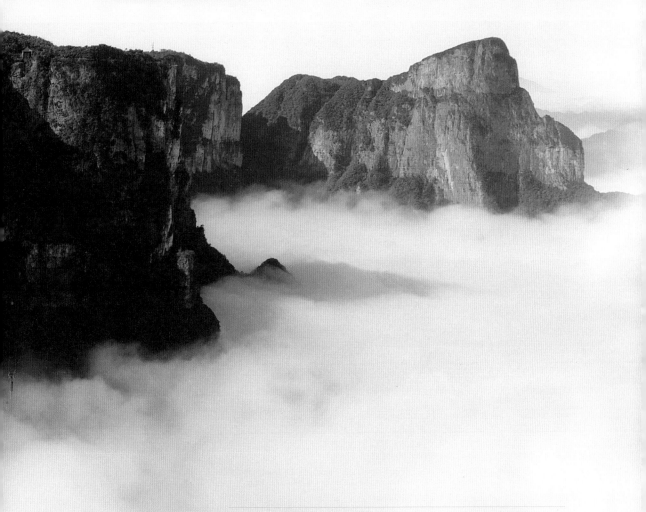

Tianmen Mountain gets its name for the natural wonder, Tianmen Cave. The cave is open as a door on the cliff up to 1,000 meters, inhaling clouds and exhaling mist, absorbing spirit of the heaven and earth. Traces of Guiguzi, auspicious unicorns and other legends have added a mysterious atmosphere for the Tianmen Mountain. Nature and humanity interweave here, and history and modernity collide here. Taking cableway through the peaks and valleys and walking the glass walkway to experience the pleasure of stepping on the clouds, and visiting the Tianmen Mountain Temple is to experience the baptism of Buddhism. On the top of the mountain there is different four-season scenery and the joy is also infinite: to enjoy the flowers in spring, to see the rosy clouds in summer, to be intoxicated by frost leaves in autumn, to hibernate in snow and ice in winter.

In 1999, Planes passed through Tianmen cave, which made Tianmen Mountain famous all over the world. Since then, more and more large-scale extreme sports events and challenges have been held here. Therefore, Tianmen Mountain has become "The holy land of extreme sports".

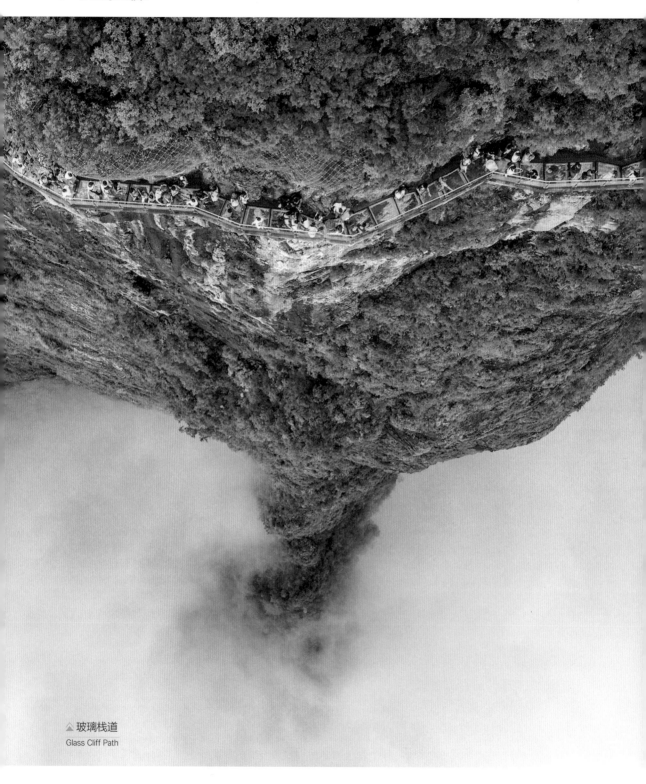

⛰ 玻璃栈道
Glass Cliff Path

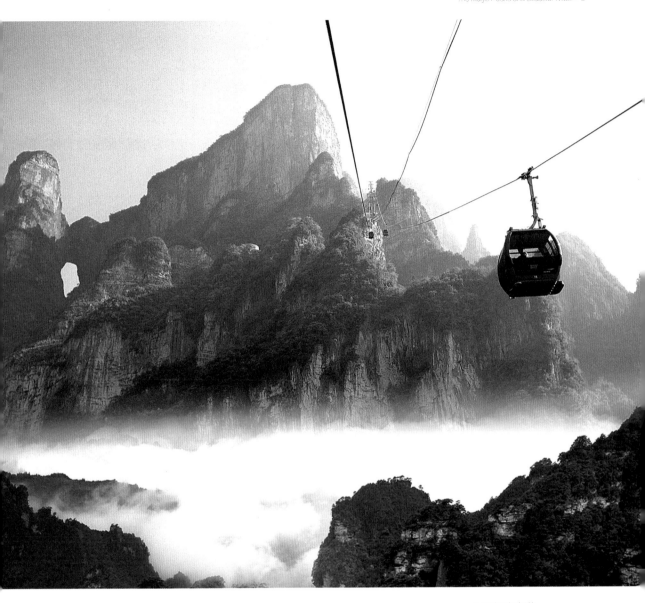

☖ 天门山索道

Tianmen Mountain Ropeway

▼ 天门山寺

Tianmen Mount Temple

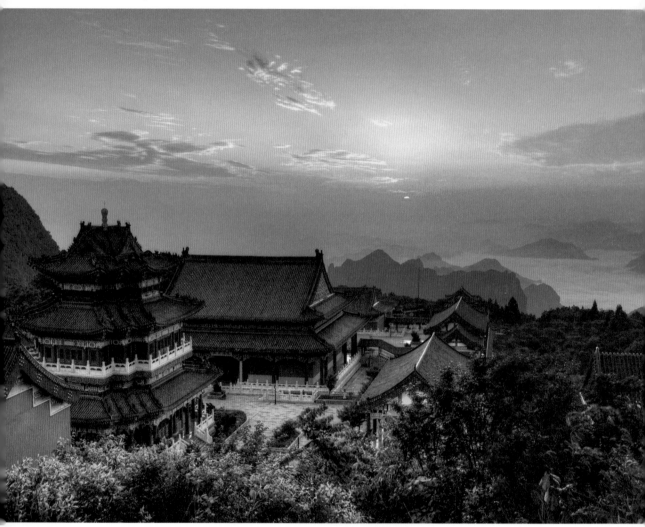

▼ 天门山盘山公路
Tianmen Mountain Winding Road

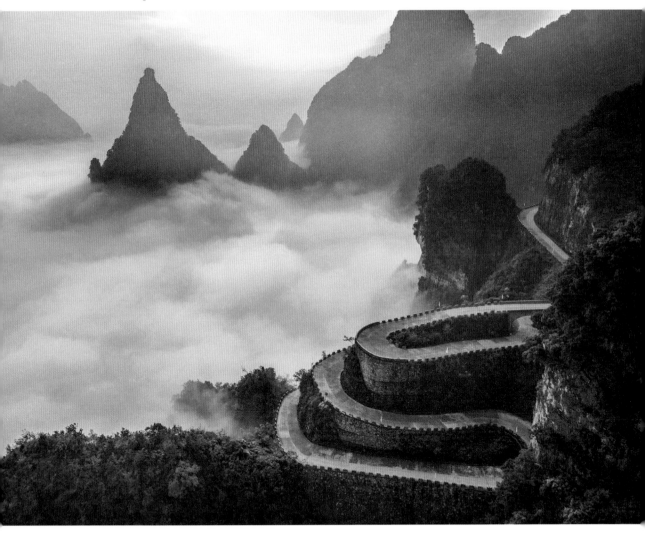

▼ 2006 年 3 月 19 日，俄罗斯空军战机飞越天门洞

On March 19, 2006, Fighter Aircraft of Russian Air Force flew through Tianmen Cave

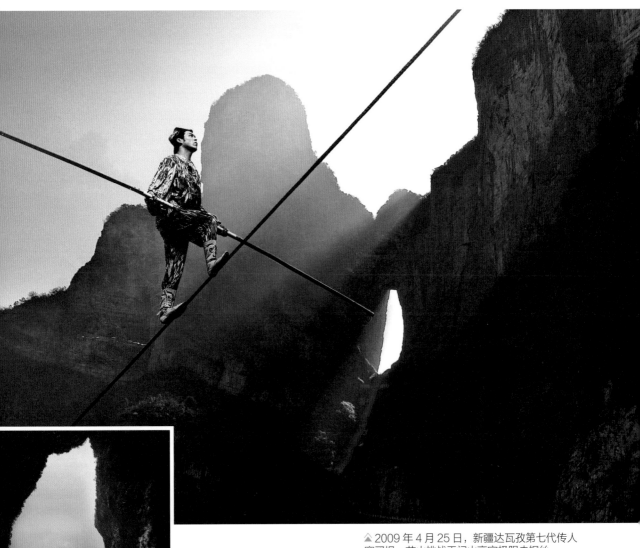

△2009 年 4 月 25 日，新疆达瓦孜第七代传人
赛买提·艾山挑战天门山高空极限走钢丝

On April 25, 2009, Maiti-Aishan from Xinjiang, the 7th
generation inheritor of Dawazi, walked tightrope at Tianmen
Mountain

◀法国蜘蛛人徒手攀爬天门山

France's "Spider Man" Climbing the
Tianmen Mountain with bare hands

大峡谷景区
Grand Canyon Scenic Spot

⯗ 国家 AAAA 级旅游景区
National AAAA Level Tourist Attraction

位于慈利县三官寺土家族乡
Located in Sanguan Temple Tujia Township, Cili County

　　张家界大峡谷全长 7.5 公里，垂直高度 400 多米，两岸峭壁挺立、古松斜挂，谷中林泉密布、瀑布飞泻，自然风光得天独厚。清澈的湖面上常年萦绕着一层薄雾，置身其间仿佛误入世外桃源。世界首座高空峡谷玻璃桥凌空飞架，宛如挂在云端，是目前世界上最高的玻璃面人行桥，入选了吉尼斯世界纪录 2019 年年鉴，拥有十项世界第一。具有蹦极、溜索、舞台表演等多种功能，吸引中外游客无数。

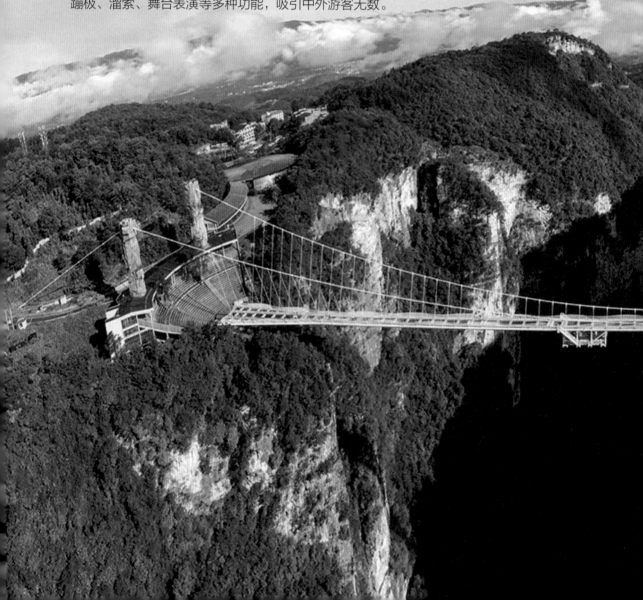

Zhangjiajie Grand Canyon is 7.5 kilometers in length and more than 400 meters in vertical height. The cliffs on both banks stand erect and the pine grows diagonally. There exit luxuriant trees, clear streams, rushing waterfalls, which contribute to the unique natural scenery. A mist wreathes the clear lake all year round, just like a land of idyllic beauty. The world's first glass bridge soars across Grand Canyon, as if hanging in the clouds, which is the highest glass pedestrian bridge, selected in Guinness World Records Yearbook 2019 and owning ten world firsts. Zhangjiajie Grand Canyon possesses bungee jumping, rope skating, stage performance and other functions, so it can attract a number of tourists at home and abroad.

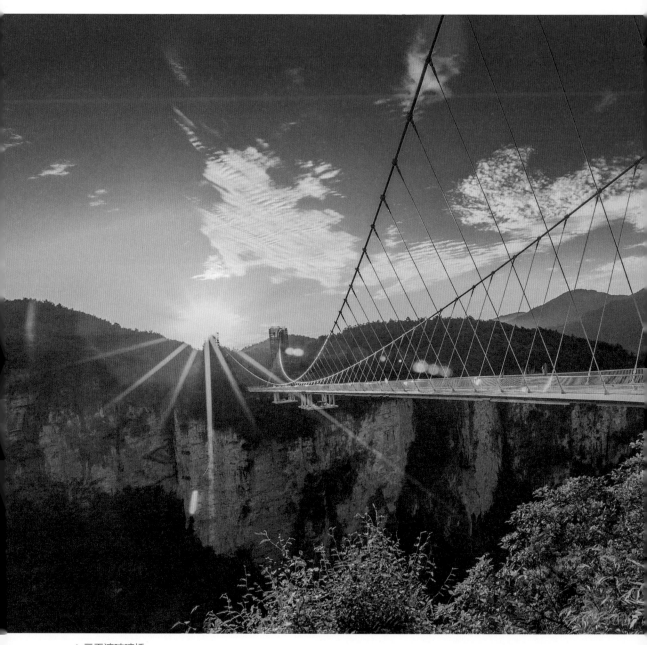

⚠ 云天渡玻璃桥

Yuntiandu Glass Bridge

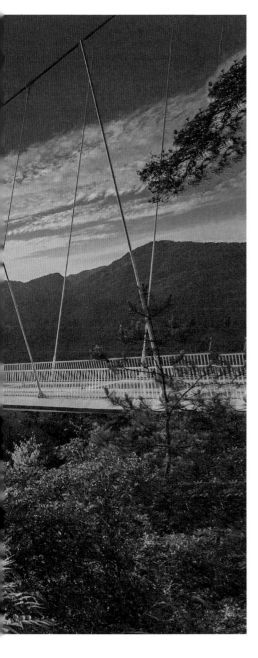

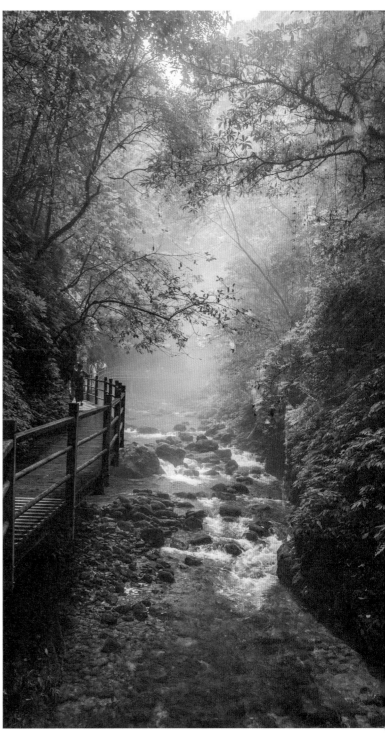

峡谷探幽▶▶

Canyon Exploration

茅岩河景区
Maoyan River Scenic Spot

国家 AAAA 级旅游景区
National AAAA Level Tourist Attraction

位于永定区茅岩河镇
Located in Maoyan River Town, Yongding District

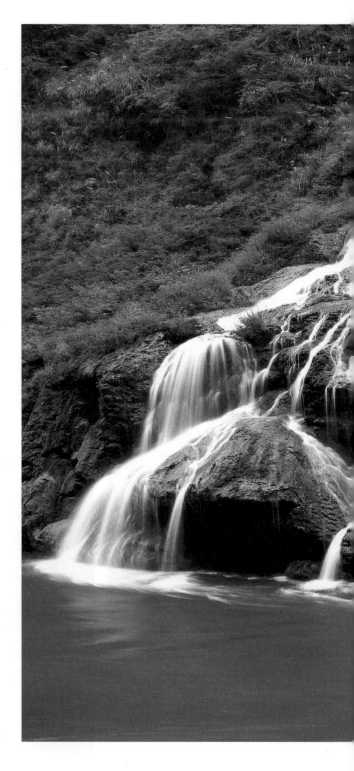

茅岩河位于澧水上游，全长50多公里，河段多险滩、急流。河水若奔，急湍似箭；瀑布从岩石间滚坠，激起碎玉无数。仙人执笔绘就了这幅青绿山水图，却不小心遗落在人间。幸而我们找到了它，才得以见到如此美丽灵动的百里画卷。游览完绝壁秀水，还可以探一探"世界奇穴之冠"的神秘溶洞，观一观古色古香的特色古寨，试一试激情澎湃的极速漂流，泡一泡宁静安逸的康养温泉……丰富的旅游资源，任君体验。

Maoyan River is located in the upstream of the Li River, with a total length of more than 50 kilometers, which has many dangerous shoals and rapids. The river flows at great speed like an arrow. The waterfall fell from the rocks, stirring countless jade. Fairy painted this green landscape painting, but accidentally left it in the world. Fortunately, we found it, only to see such a beautiful and clever picture scroll. After visiting the cliff and beautiful water, we can also explore the mysterious "the crown of the world strange cave", view the ancient characteristic ancient village, try the passionate high-speed rafting, and soak in a quiet and comfortable health hot spring... These rich tourism resources are here for you to experience.

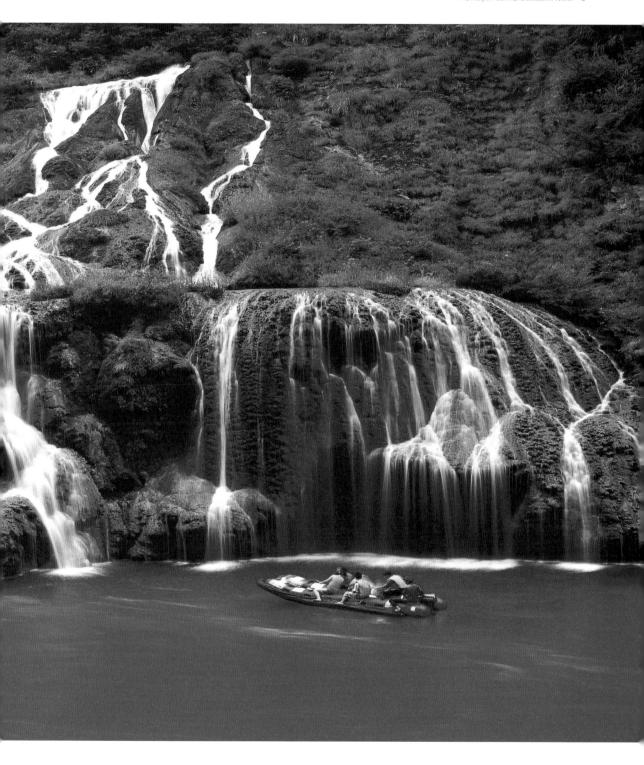

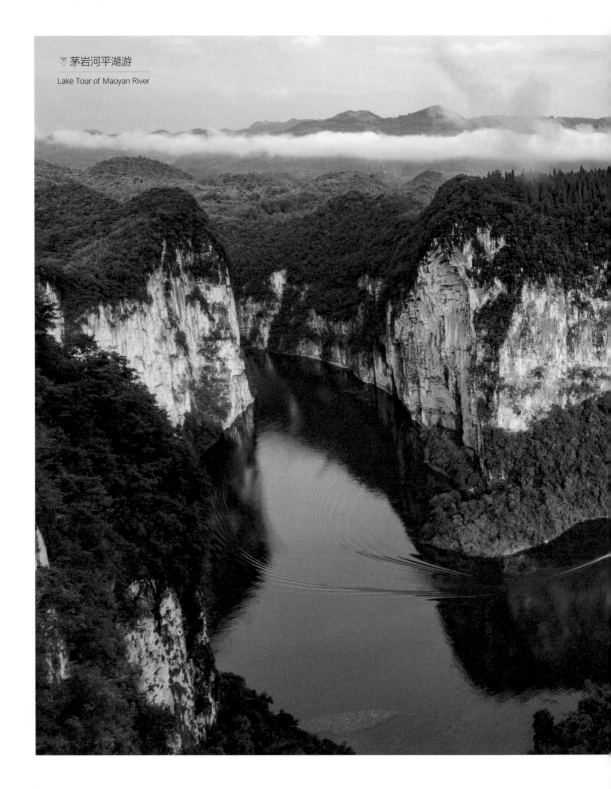

▼ 茅岩河平湖游
Lake Tour of Maoyan River

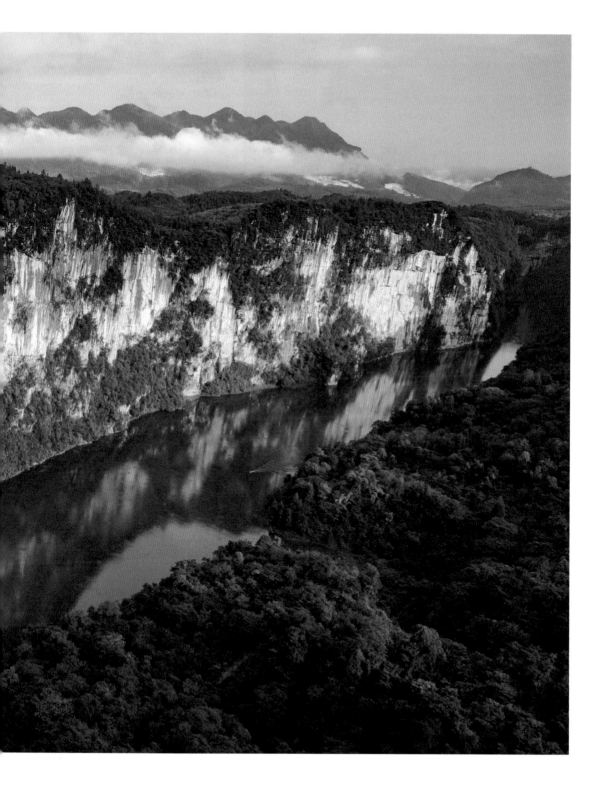

▲苦竹寨

Kuzhu Village

▲九天玄女洞

Empyrean Fairy Cave

▼峰恋溪

Fenglian Stream

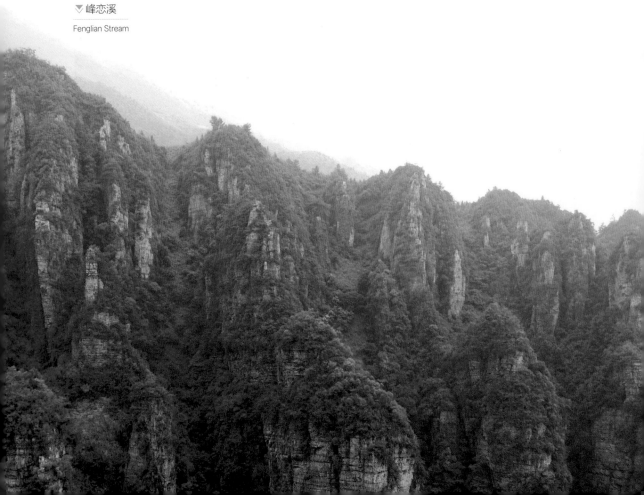

⛰ 心湖

Heart Lake

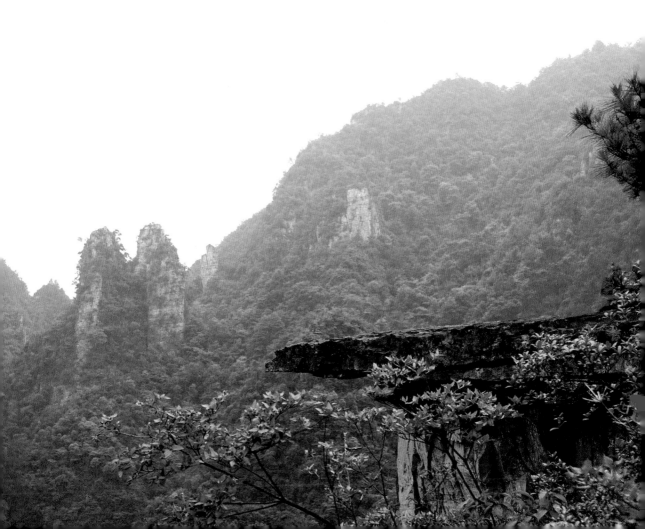

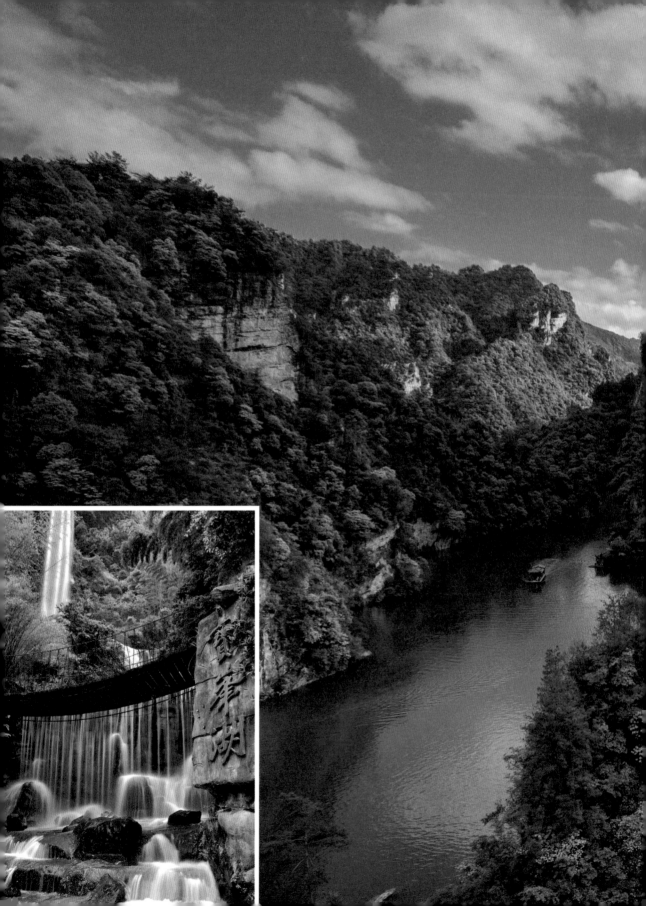

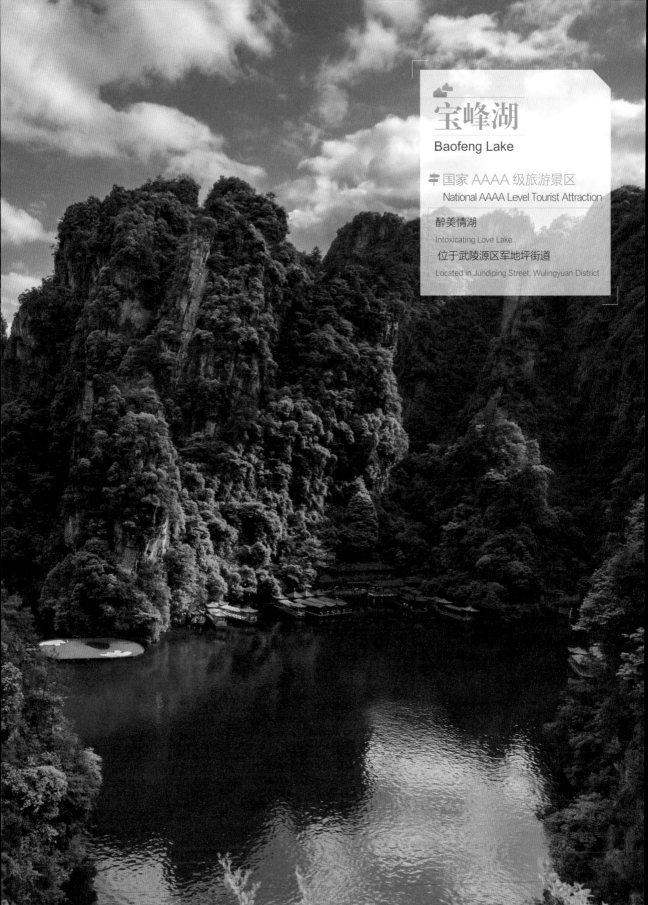

宝峰湖
Baofeng Lake

国家 AAAA 级旅游景区
National AAAA Level Tourist Attraction

醉美情湖
Intoxicating Love Lake

位于武陵源区军地坪街道
Located in Jundiping Street, Wulingyuan District

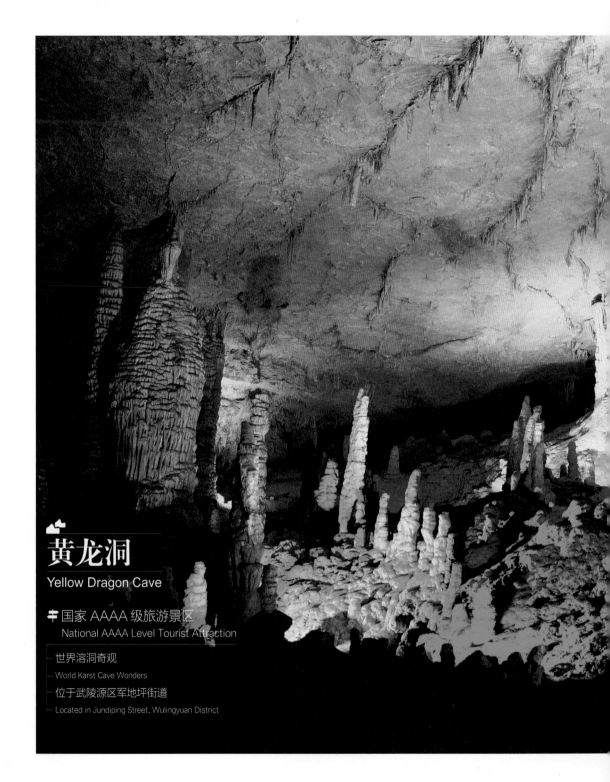

黄龙洞
Yellow Dragon Cave

国家 AAAA 级旅游景区
National AAAA Level Tourist Attraction

— 世界溶洞奇观
— World Karst Cave Wonders
— 位于武陵源区军地坪街道
— Located in Jundiping Street, Wulingyuan District

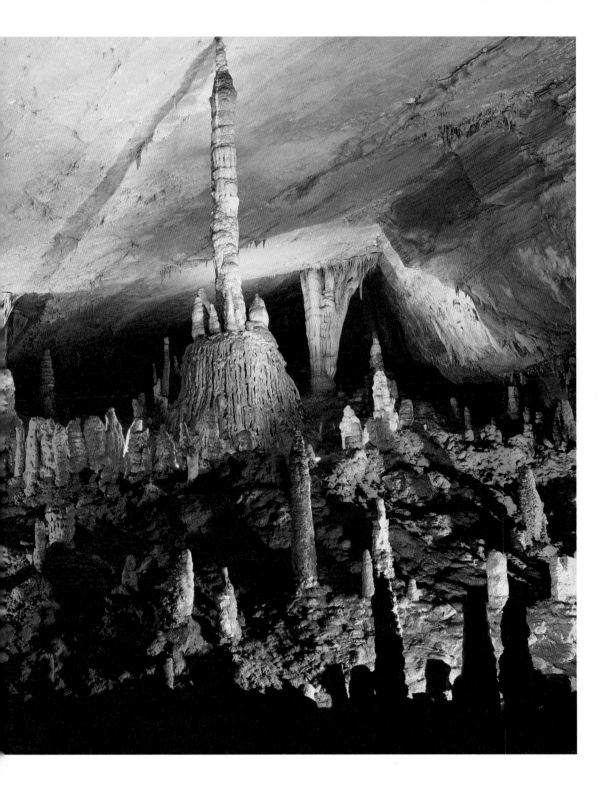

龙王洞
Dragon King Cave

国家 AAAA 级旅游景区
National AAAA Level Tourist Attraction

地心之门
The Door to the Earth's Core

位于慈利县三官寺土家族乡
Located in Sanguan Temple Tujia Township,
Cili County

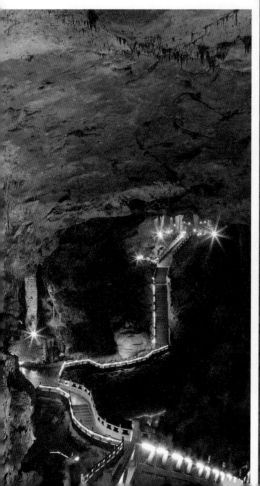

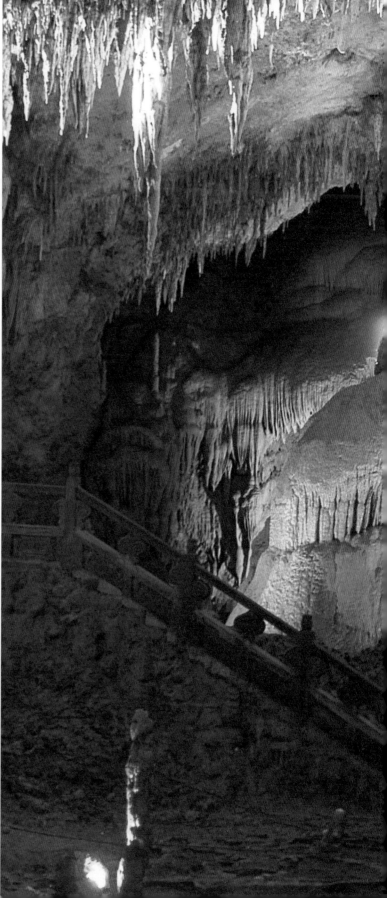

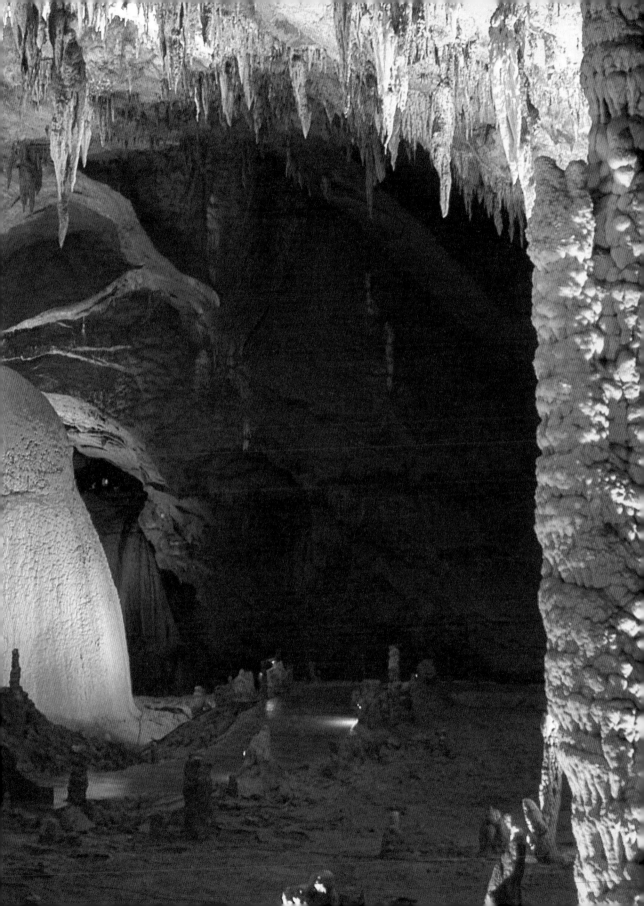

张家界地缝

Zhangjiajie Ravine

国家 AAAA 级旅游景区
National AAAA Level Tourist Attraction

四季如一的奇境
One-season-all-the-year Wonderland

位于慈利县零溪镇
Located in Lingxi Town, Cili County

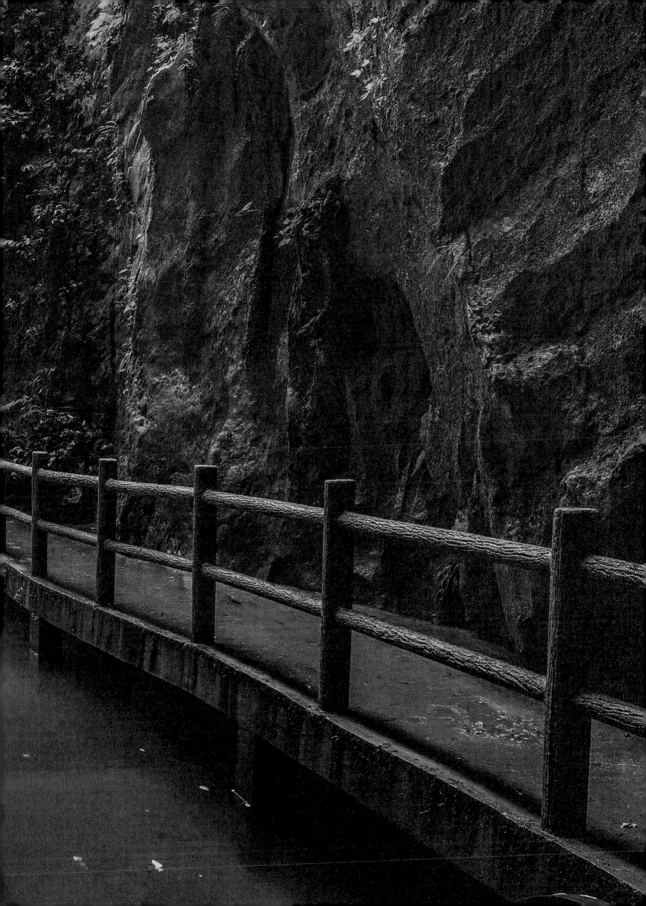

七星山

Seven-star Mountain

湖南省省级旅游度假区
Hunan Provincial Level Tourist Resort

我要爱你，一生一世
I'll love you all my life

位于永定区天门山镇
Located in Tianmen Mount Town, Yongding
District

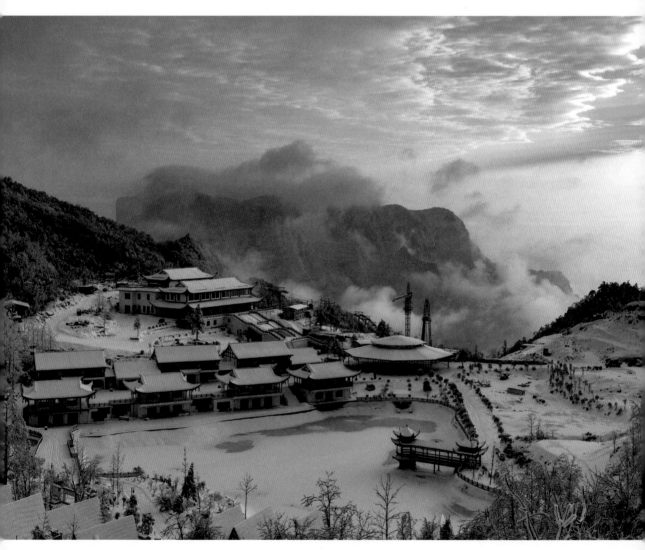

▼ 七星山 "1520 天空之眼"
"1520 Eye in The Sky" on Seven-star Mountain

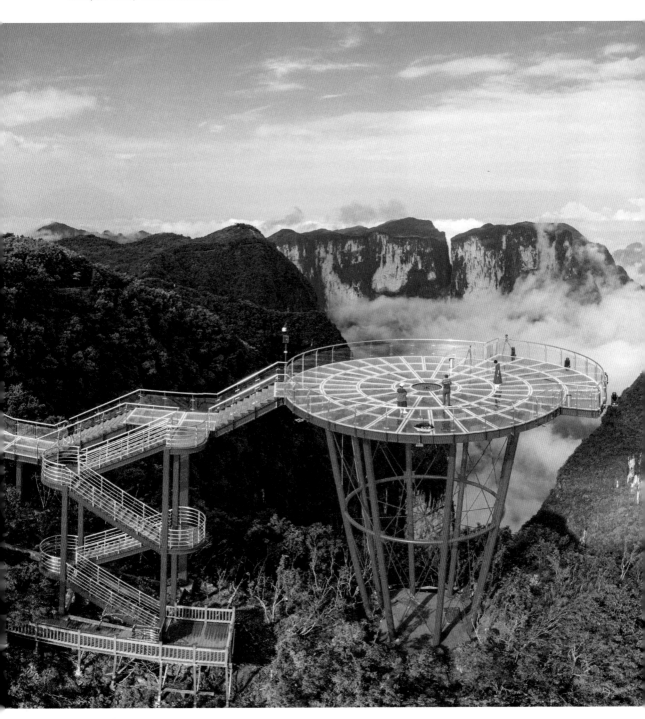

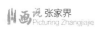

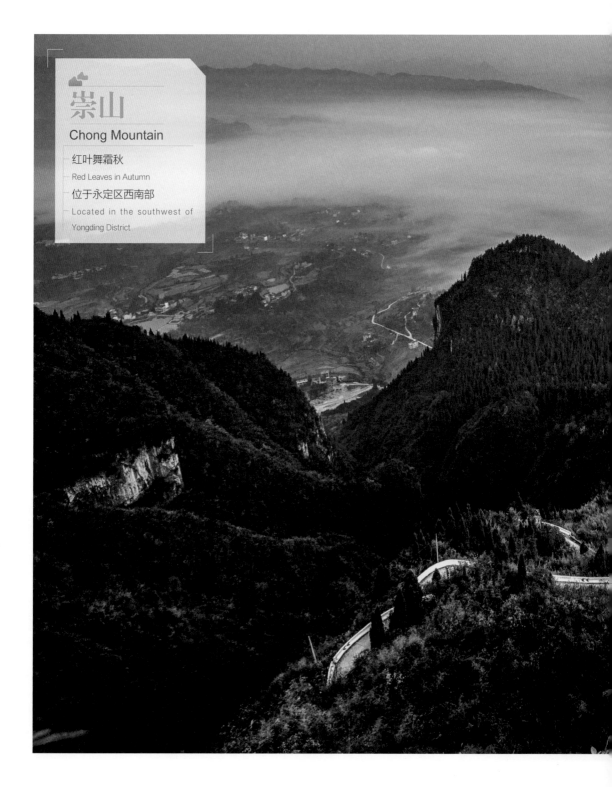

崇山
Chong Mountain

红叶舞霜秋
Red Leaves in Autumn

位于永定区西南部
Located in the southwest of
Yongding District

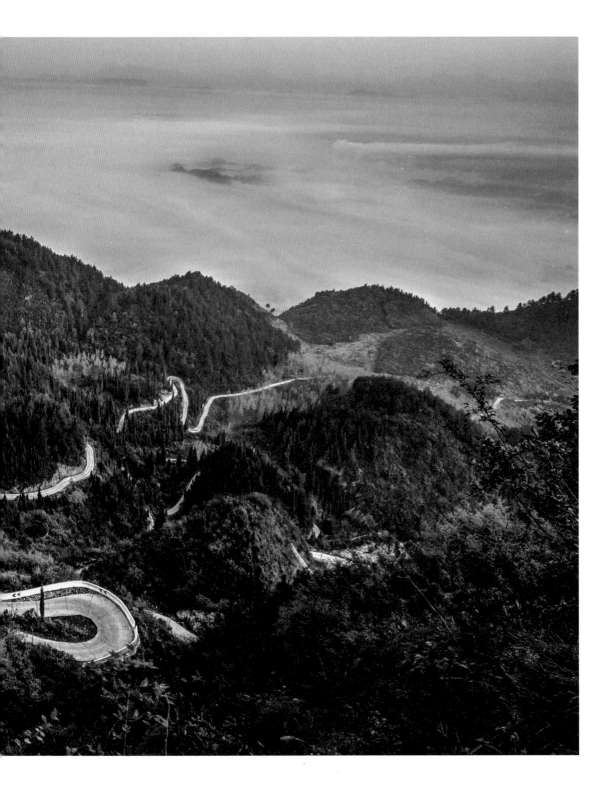

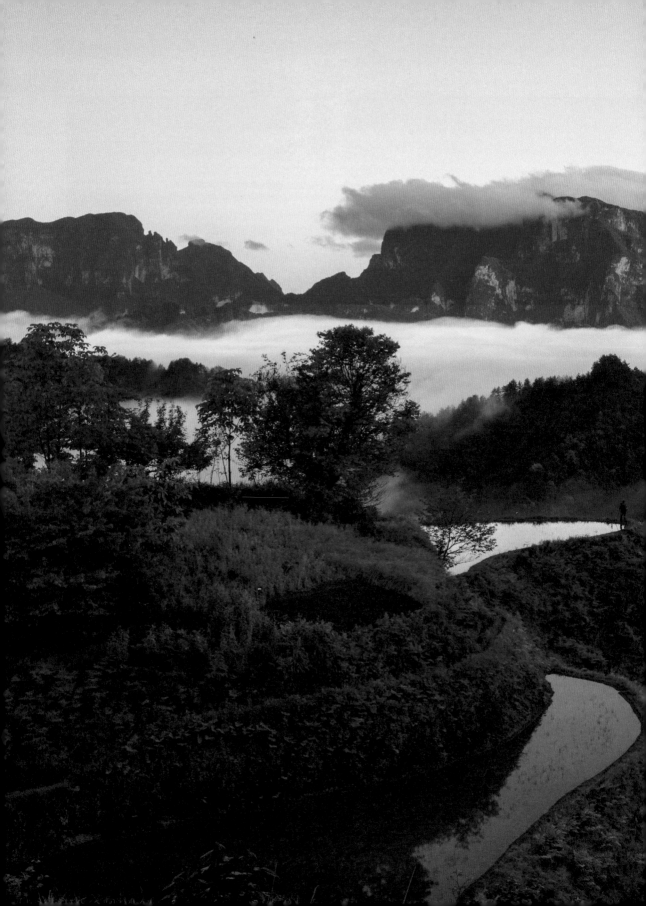

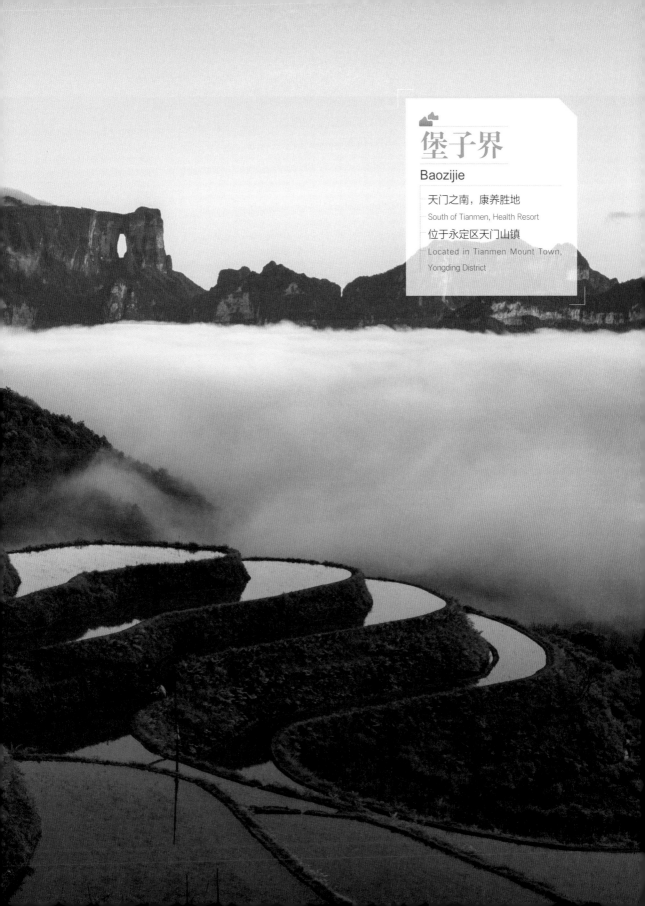

堡子界

Baozijie

天门之南，康养胜地
South of Tianmen, Health Resort

位于永定区天门山镇
Located in Tianmen Mount Town, Yongding District

南滩草场
Nantan Grassland

— 中国南方最大的天然草场之一
— One of the largest natural grasslands in South China
— 位于桑植县人潮溪镇
— Located in Renchaoxi Town, Sangzhi County

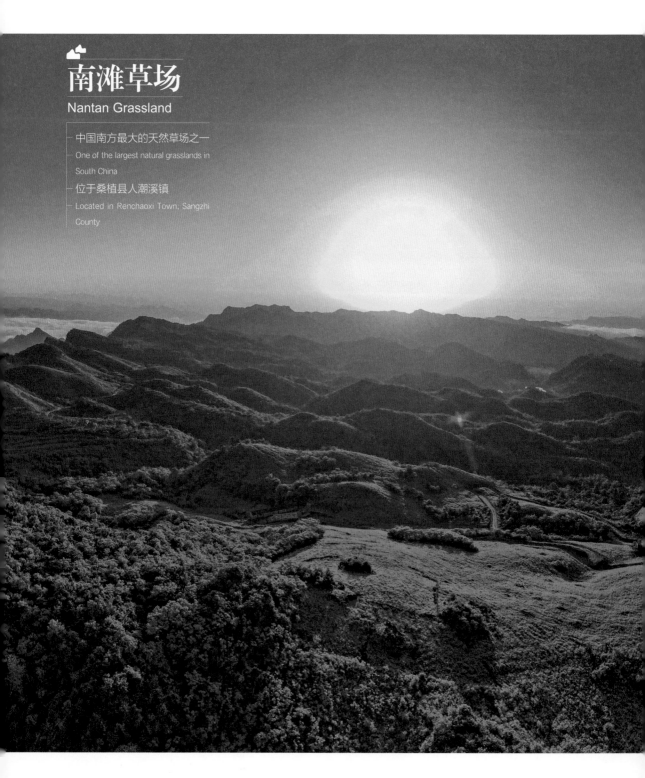

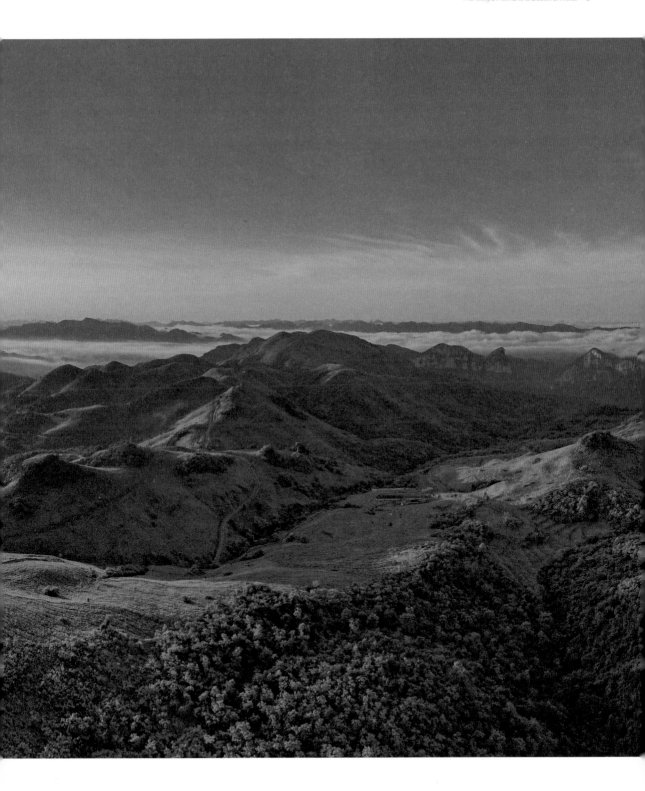

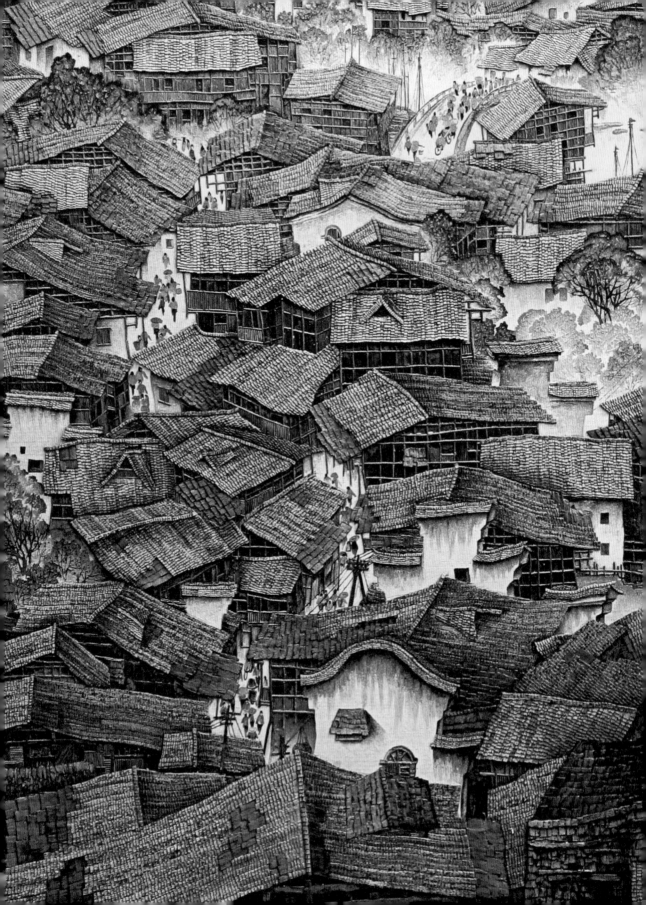

水，时而汉隶，时而魏碑；
山，时而水墨，时而重彩；
时光，时而静守，时而如流。
岁月不败，勇者弥坚。
张家界，以山水为盟，守城市不息文脉；
以涓滴之流，护城市生命之根。

The rivers possess the charm of different styles of
calligraphy sometimes like Han clerical script, sometimes
like Wei tablets.
The mountains are just like paintings of different styles,
sometimes in Chinese ink style, sometimes in heavy colors.
Time sometimes remains still, but sometimes keeps
flowing.
As years go by, the brave will be stronger.
Zhangjiajie, mountains and water as its allies, protects its
endless culture;
Zhangjiajie, with a trickle of the stream, defends its root
of life.

人文荟萃

Gathering
of Talents

薪火相传

Inheriting the Red Gene

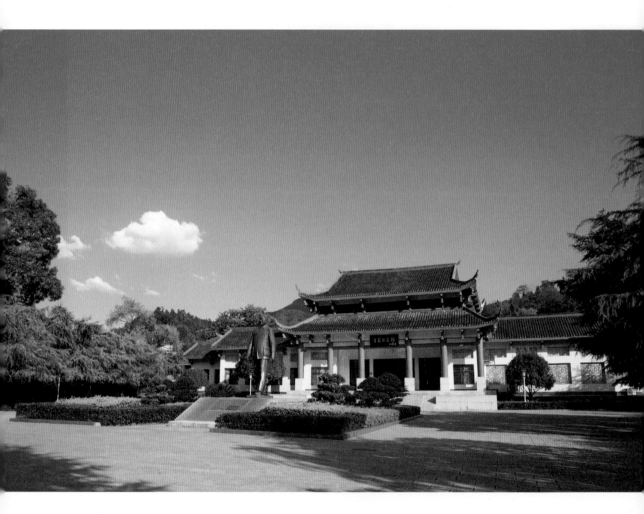

贺龙纪念馆

He Long Memorial Hall

国家 AAAA 级旅游景区
National AAAA Level Tourist Attraction

全国爱国主义教育示范基地
National Patriotism Education Demonstration Base

位于桑植县洪家关白族乡
Located in Hongjiaguan Bai Township, Sangzhi County

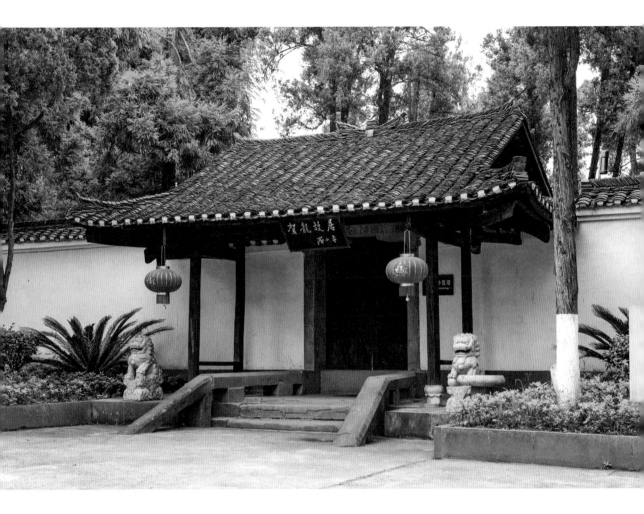

贺龙故居

The Former Residence of He Long

全国爱国主义教育示范基地
National Patriotism Education
Demonstration Base

位于桑植县洪家关白族乡
Located in Hongjiaguan, Bai
Township, Sangzhi County

中国工农红军第二方面军长征出发地纪念馆

The Memorial Hall for the Long March of the Second Front
Army of the Chinese Workers' and Peasants' Red Army

国家 AAAA 级旅游景区
National AAAA Level Tourist Attraction

全国爱国主义教育示范基地
National Patriotism Education Demonstration Base

位于桑植县刘家坪白族乡
Located in Liujiaping, Bai Township, Sangzhi County

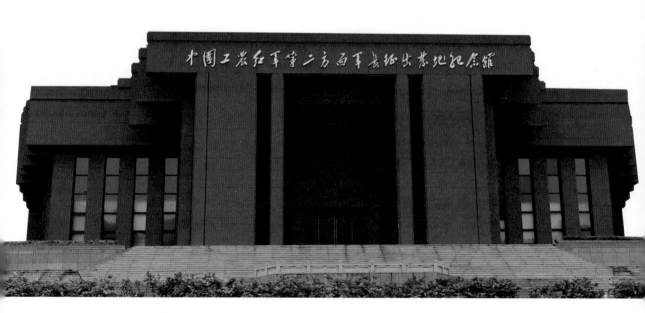

湘鄂川黔革命根据地
纪念馆

Memorial Hall of Hunan-Hubei-Sichuan-Guizhou Revolutionary Base

— 全国爱国主义教育示范基地
— National Patriotism Education Demonstration Base
— 位于永定区永定街道
— Located in Yongding Street, Yongding District

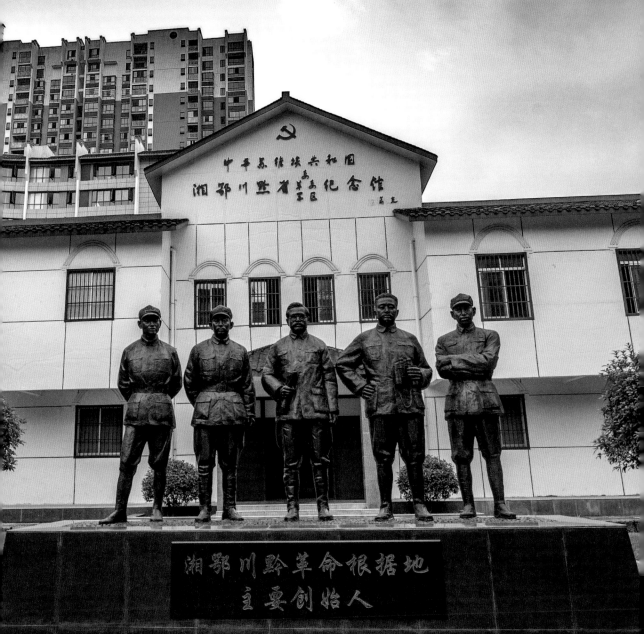

廖汉生故居

The Former Residence of Liao Hansheng

- 湖南省爱国主义教育基地
- Hunan Patriotism Education Base
- 位于桑植县桥自弯镇
- Located in Qiaoziwan Town, Sangzhi County

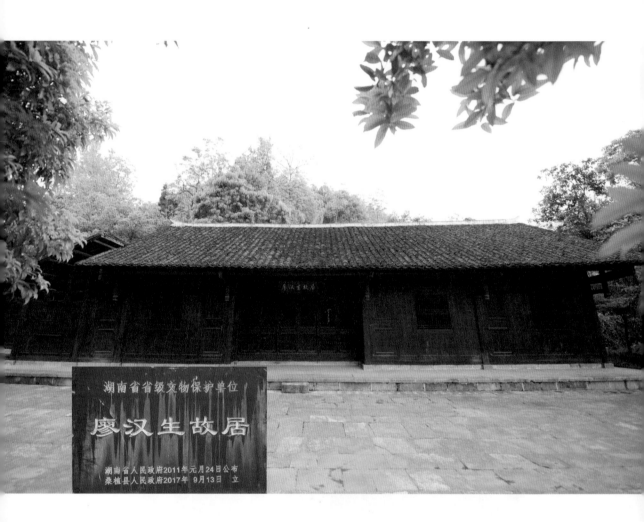

贺龙公园

He Long Park

湖南省爱国主义教育基地
Hunan Patriotism Education Base
位于武陵源区天子山风景区
Located in Tianzi Mount Scenic
Spot, Wulingyuan District

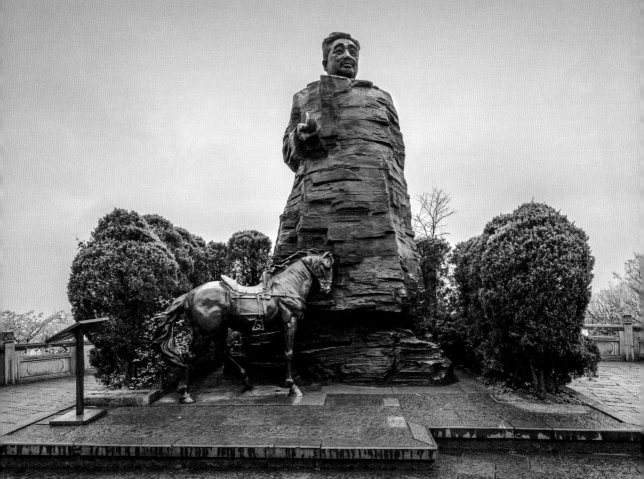

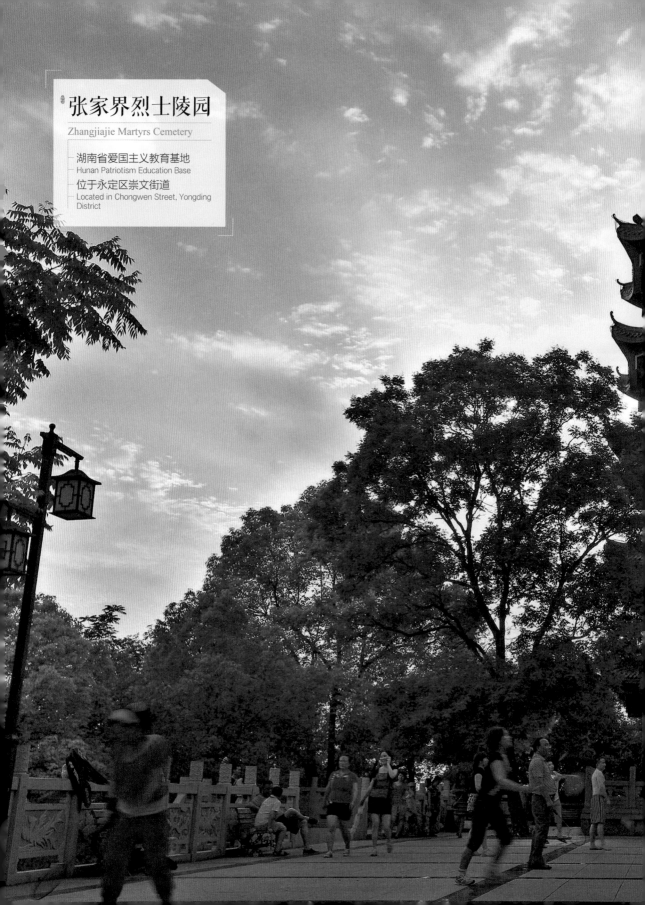

张家界烈士陵园

Zhangjiajie Martyrs Cemetery

—湖南省爱国主义教育基地
— Hunan Patriotism Education Base
—位于永定区崇文街道
— Located in Chongwen Street, Yongding
District

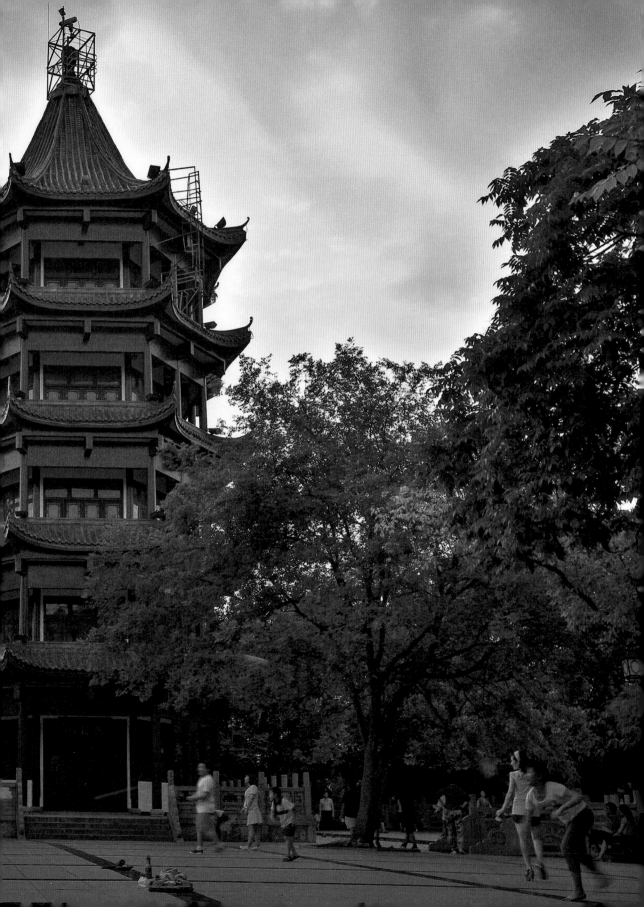

时光余韵
Time Charm

桑植民歌
Sangzhi Folk Songs

— 国家级非物质文化遗产
— National Intangible Cultural Heritage

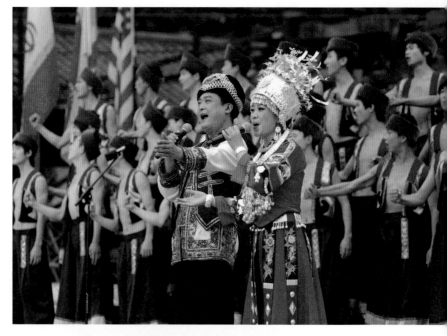

桑植仗鼓舞
Sangzhi Battle-drum Dance

— 国家级非物质文化遗产
— National Intangible Cultural Heritage

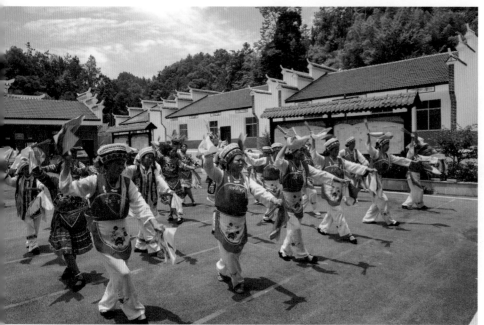

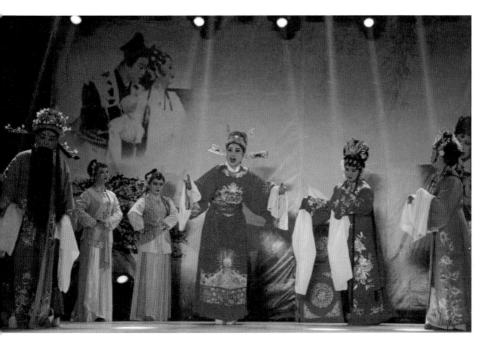

张家界阳戏
Zhangjiajie Yang Opera

国家级非物质文化遗产
National Intangible Cultural
Heritage

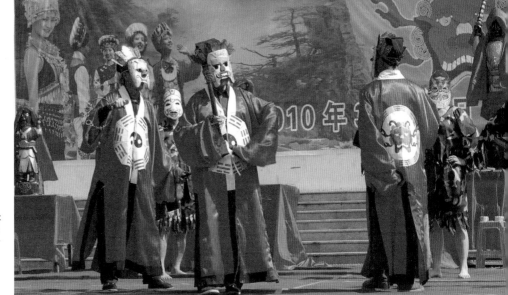

土家族撒叶儿嗬
jia Sayeryo

国家级非物质文化遗产
National Intangible Cultural Heritage

板板龙灯

Board Dragon Lantern

国家级非物质文化遗产
National Intangible Cultural Heritage

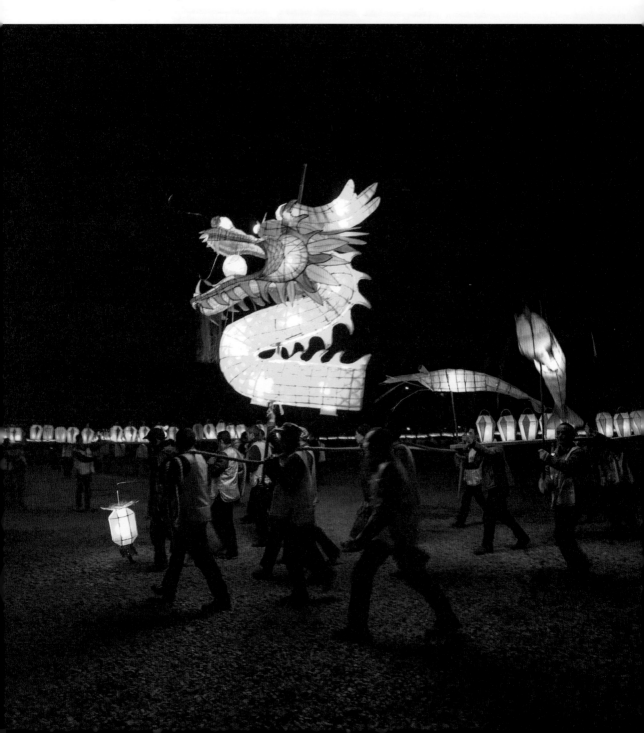

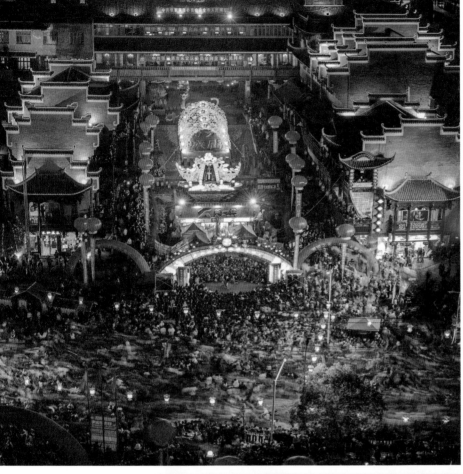

元宵灯会

The Lantern Festival

土家年

Tujia New Year

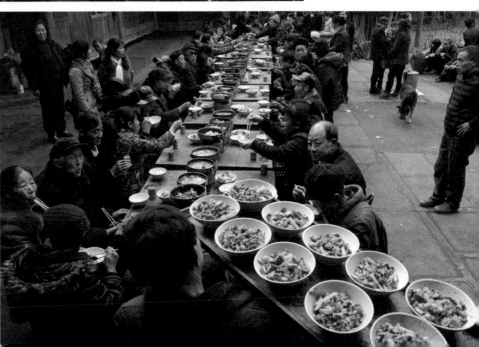

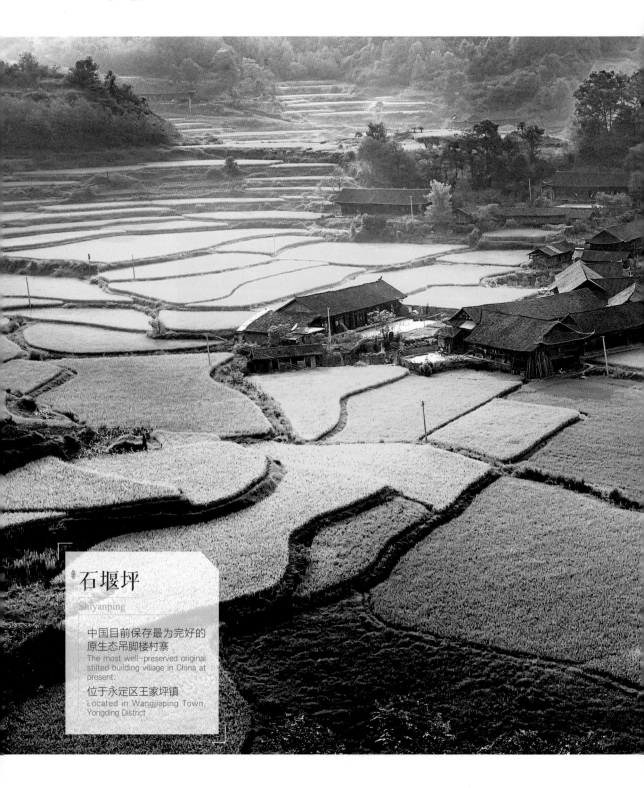

石堰坪

Shiyanping

中国目前保存最为完好的
原生态吊脚楼村寨
The most well-preserved original
stilted building village in China at
present.

位于永定区王家坪镇
Located in Wangjiaping Town,
Yongding District

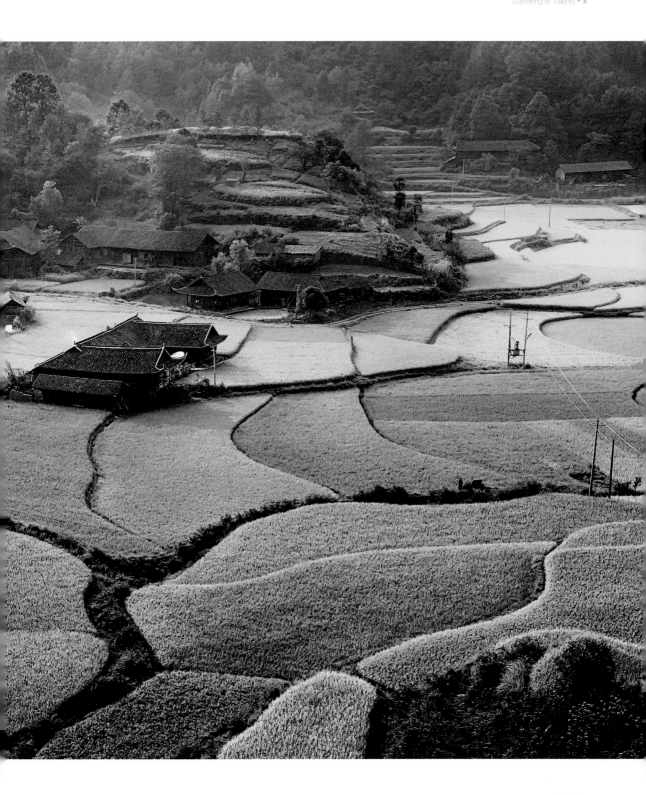

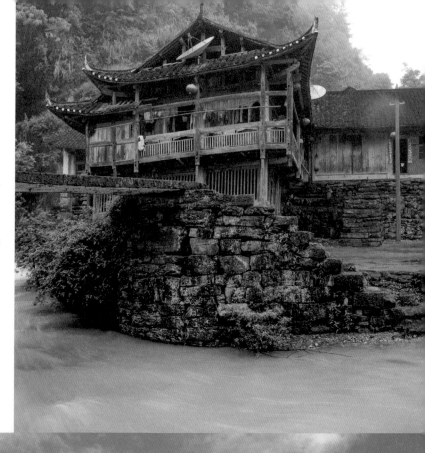

马头溪

Horse Head Stream

中国少数民族特色村寨
Chinese Ethnic Minority Village

位于永定区王家坪镇
Located in Wangjiaping Town, Yongding District

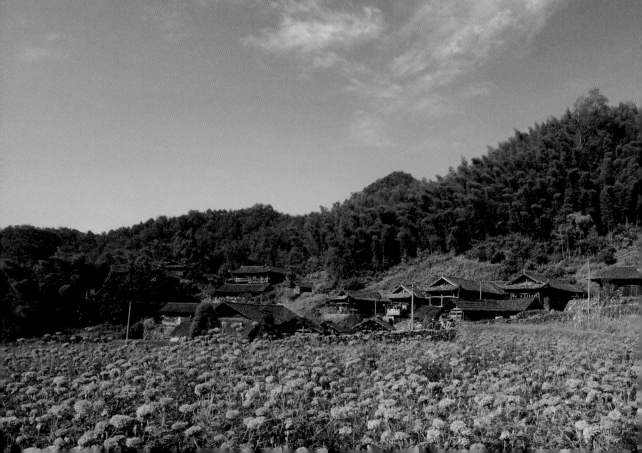

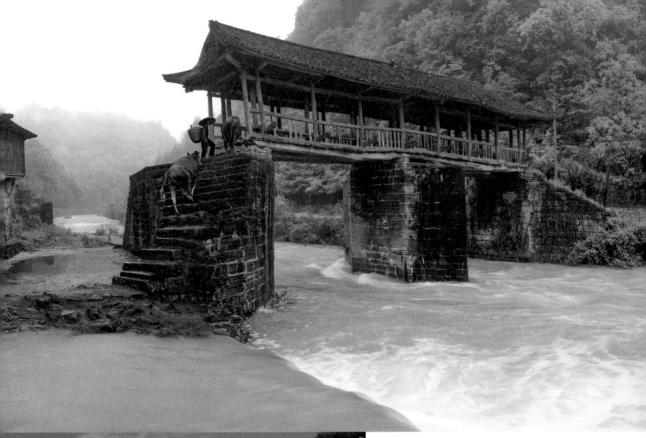

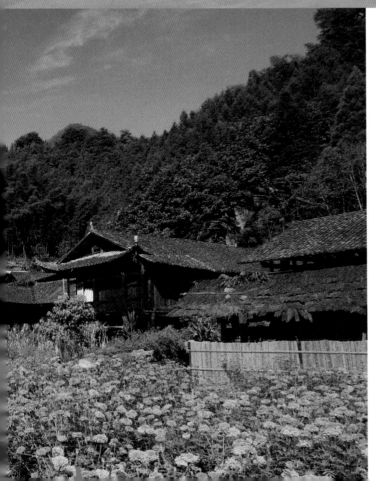

牧笛溪

The Cowherd's Flute Stream

电视剧《江山如此多娇》拍摄地
A filming Place of TV Drama *A Land So Rich in Beauty*

位于永定区四都坪乡
Located in Siduping Township, Yongding District

土家风情园

Tujia Folk Customs Park

— 南方紫禁城
— The Southern Forbidden City

— 国家 AAAA 级旅游景区
— National AAAA Level Tourist Attraction

— 位于永定区南庄坪街道
— Located in Nanzhuangping Street, Yongding District

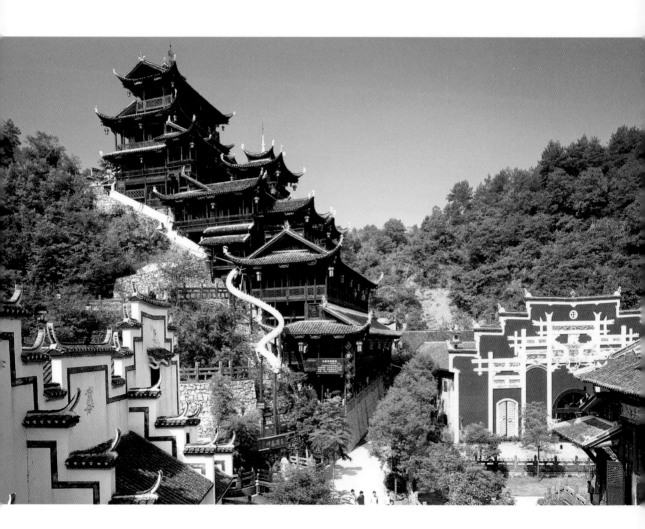

田家大院

Tian Family Courtyard

世代书香，人才辈出
A literary family, talents from
generation to generation

国家 AAA 级旅游景区
National AAA Level Tourist
Attraction

位于永定区西溪坪街道
Located in Xixiping Street,
Yongding District

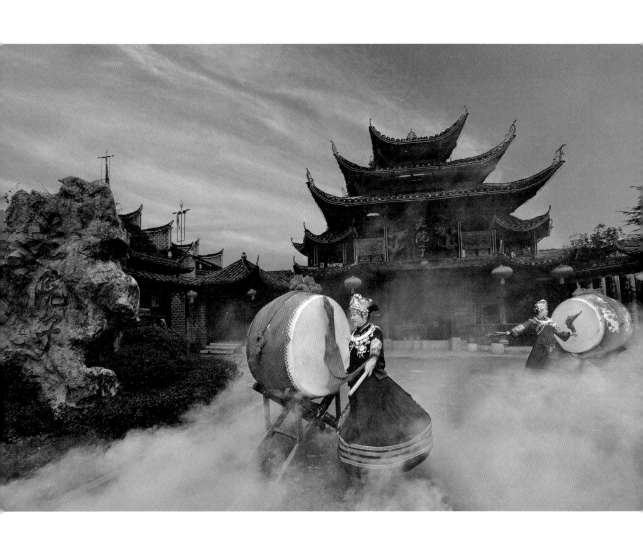

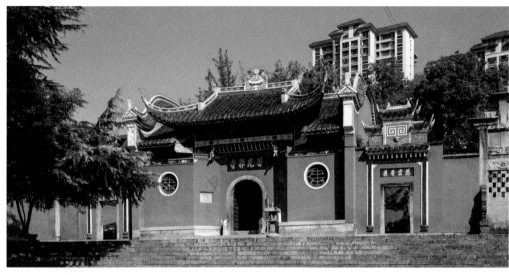

普光禅寺

Puguang Temple

闹市取幽，古色古香
— A tranquil place with antique beauty in downtown area
位于永定区永定街道
— Located in Yongding Street, Yongding District

渔浦书院

Yupu Academy

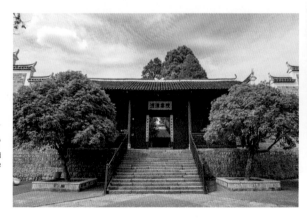

渔猎群经，导扬百氏；浦云十色，溪月九霄
— The couplet means that we should be well-read and further develop ancestors' wisdom and learning, and we can enjoy beautiful view here
位于慈利县阳和土家族乡
— Located in Yanghe Tujia Township, Cili County

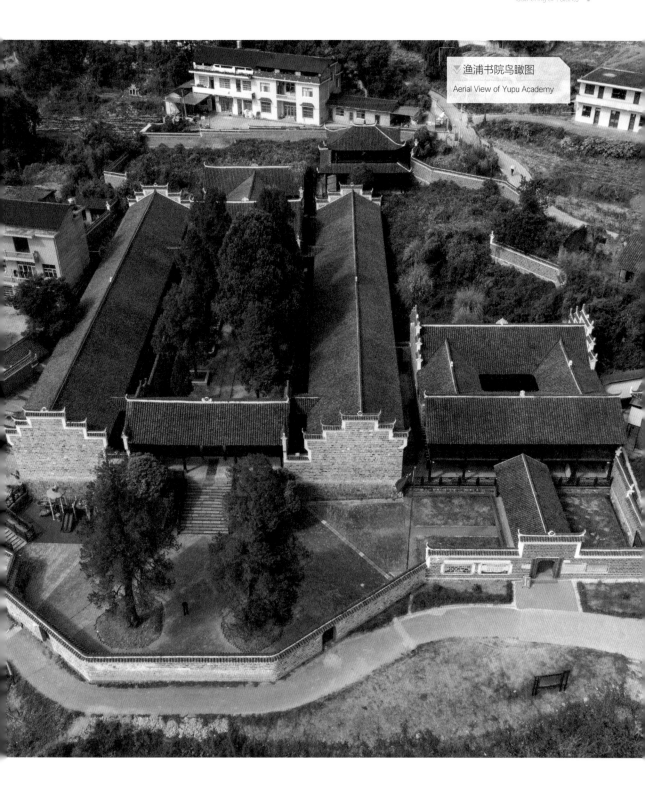

▼ 渔浦书院鸟瞰图
Aerial View of Yupu Academy

五雷山

Wulei Mountain

中国南武当
Southern Wudang in China

国家 AAA 级旅游景区
National AAA Level Tourist Attraction

位于慈利县零阳街道
Located in Lingyang Street, Cili County

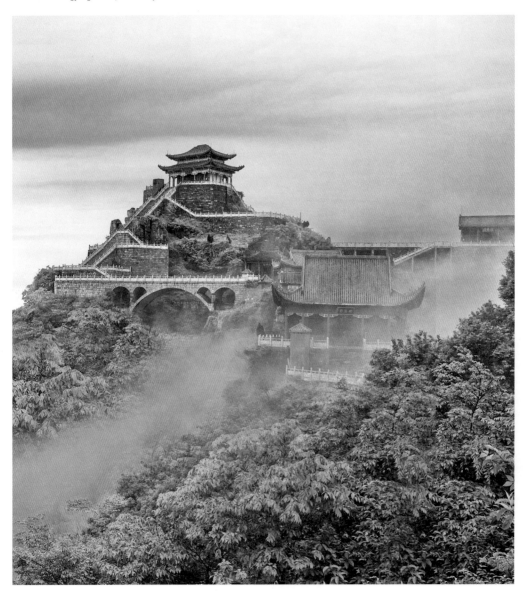

四十八寨

48 Villages

寨寨是风景，寨寨有传说
— Every village is a landscape, and
every village has a legend
位于慈利县广福桥镇
Located in Guangfu Bridge Town,
Cili County

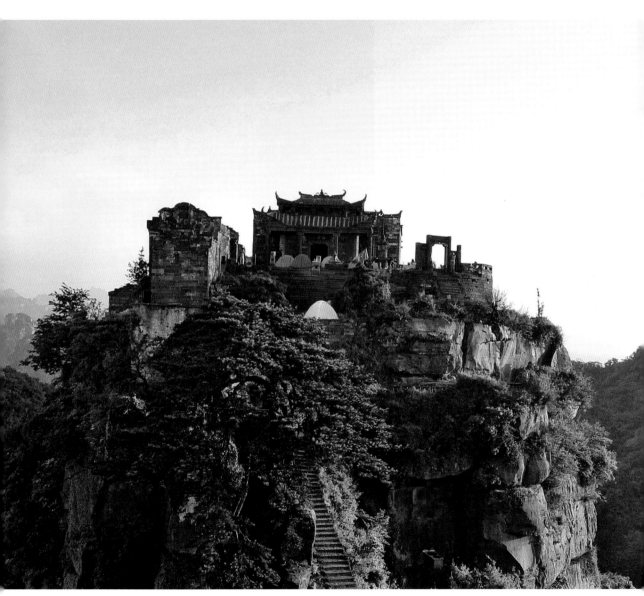

山水艺苑
Culture and Arts Show

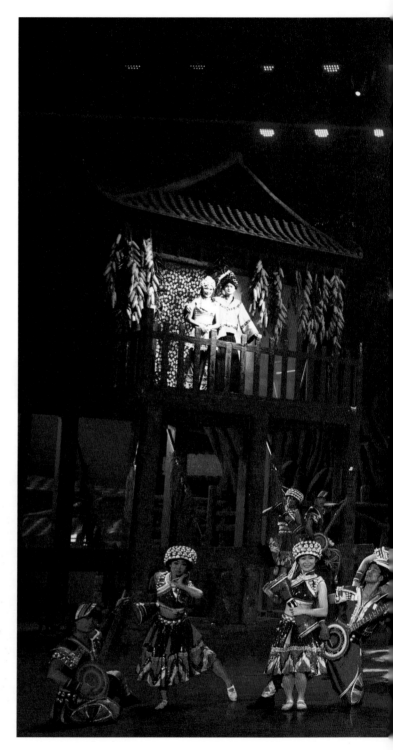

《张家界·魅力湘西》

Zhangjiajie·Charming Western Hunan

千年神秘，一台大戏
A Large-scale Show of the Long History of
Mysterious Western Hunan

位于武陵源区军地坪街道
Located in Jundiping Street, Wulingyuan District

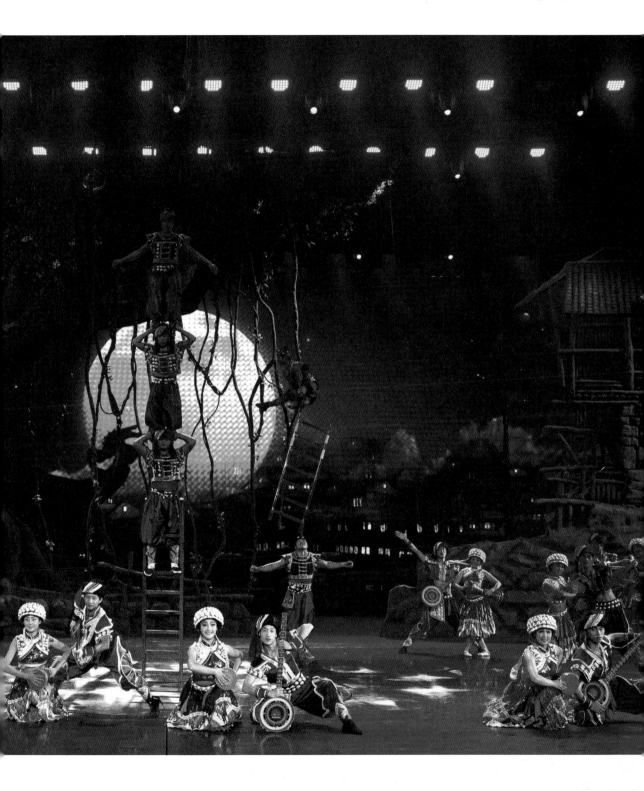

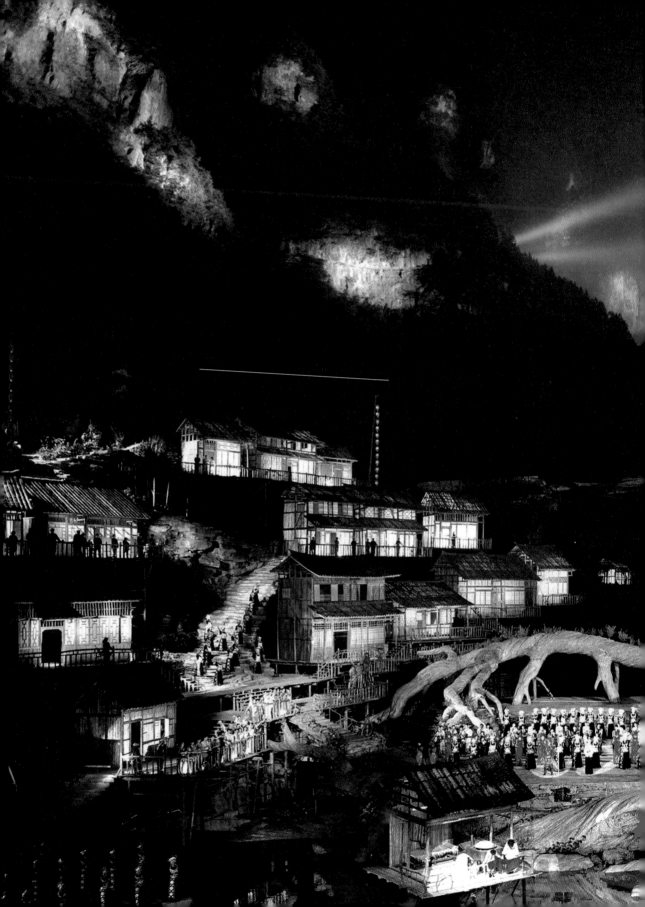

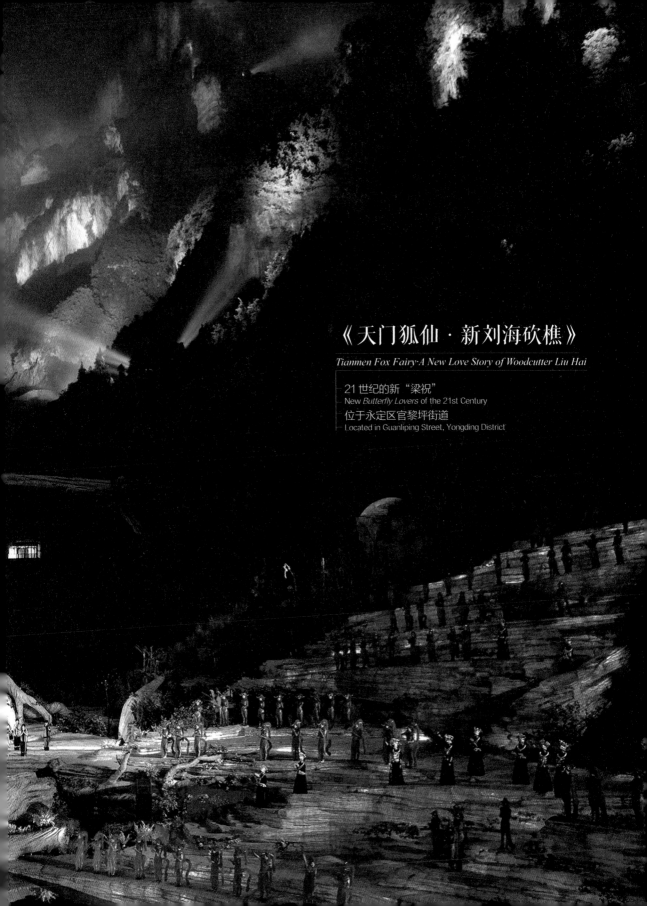

《天门狐仙·新刘海砍樵》

Tianmen Fox Fairy·A New Love Story of Woodcutter Liu Hai

- 21 世纪的新 "梁祝"
- New *Butterfly Lovers* of the 21st Century
- 位于永定区官黎坪街道
- Located in Guanliping Street, Yongding District

《张家界千古情》

The Romance of Zhangjiajie

给我一天，还你一千年
— A day for me, one thousand years for you
位于武陵源区军地坪街道
— Located in Jundiping Street, Wulingyuan District

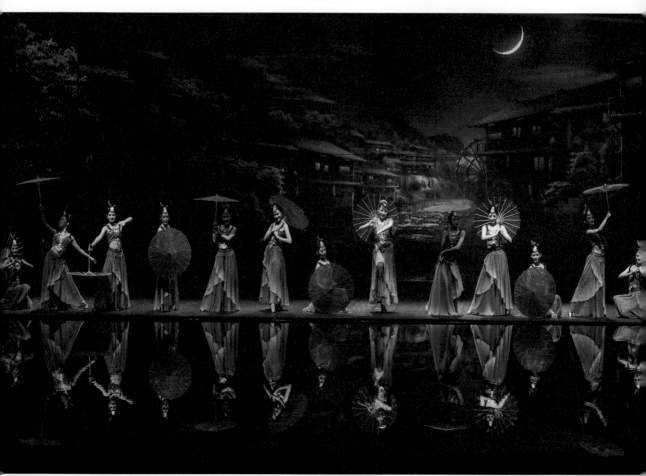

◀ 爱在湘西

Love in Western Hunan

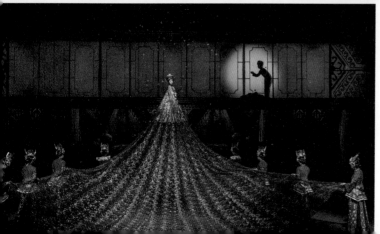

《烟雨张家界》

Zhangjiajie Drama Show

大型民族风情歌舞剧
Large-scale Folk-custom Song
and Dance Drama

位于武陵源区军地坪街道
Located in Jundiping Street,
Wulingyuan District

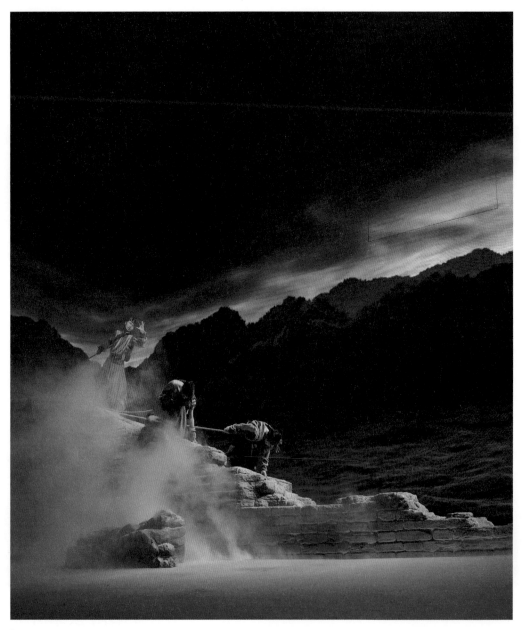

《遇见大庸》

Meeting Ancient Dayong City

张家界首部大型沉浸式体验剧
First Large-scale Immersive Experience Drama of Zhangjiajie

位于永定区崇文街道
Located in Chongwen Street, Yongding District

《张家界元宇宙·夜游九歌山鬼》

Zhangjiajie Metaverse·Nine Songs & the Mountain Spirit

元宇宙行浸式夜游
— Metaverse Linear Immersive Night Tour

位于慈利县三官寺土家族乡
— Located in Sanguan Temple Tujia Township, Cili County

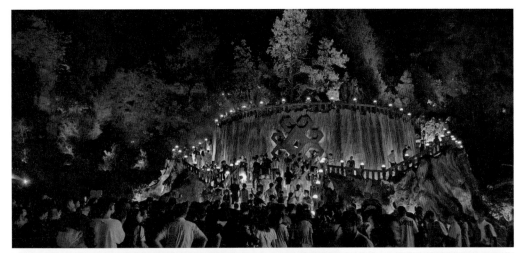

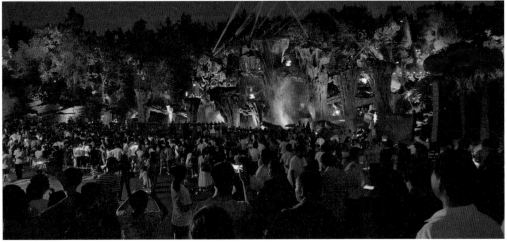

桑植民歌节

Sangzhi Folk Song Festival

桑植是"中国民歌之乡",桑植民歌已被列入首批国家级非物质文化遗产名录。2008年11月19日,首届中国桑植民歌节在桑植县民歌广场开幕,现已成功举办5届。

Sangzhi is "the hometown of Chinese folk songs", and Sangzhi folk songs have been included in the first batch of National Intangible Cultural Heritage List. On November 19, 2008, the first China Sangzhi Folk Song Festival was opened in Sangzhi County Folk Song Square, and now it has been successfully held for 5 sessions.

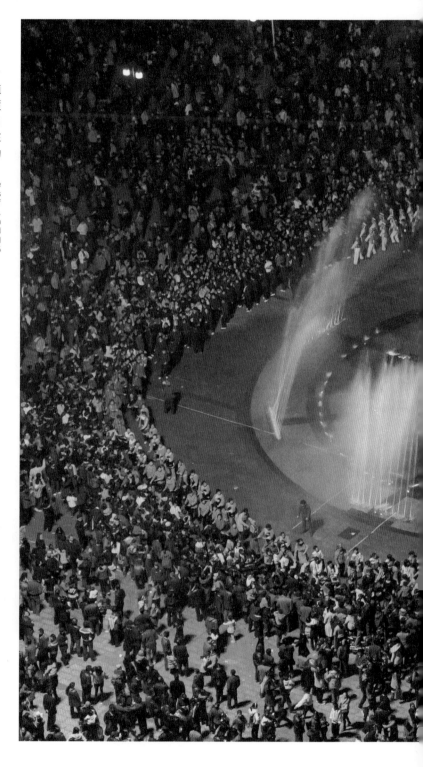

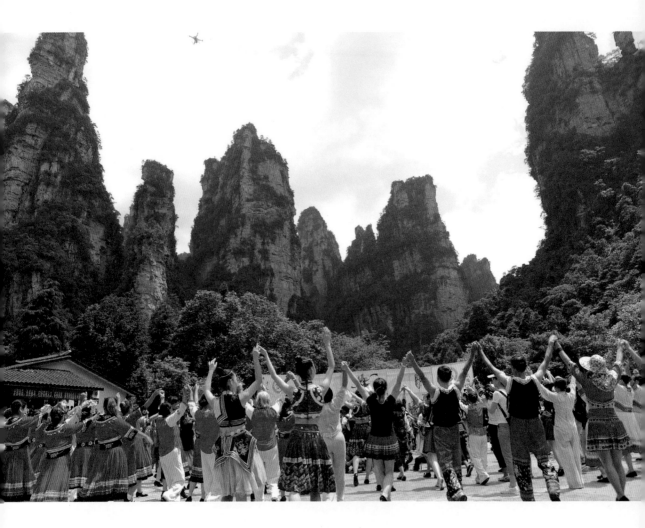

张家界民俗文化活动月

Zhangjiajie Folk Culture Activity Month

2016 年 7 月 9 日，首届中国湖南·张家界民俗文化活动月在张家界土司城拉开帷幕，现已成功举办 3 届。

On July 9, 2016, the first China Hunan Zhangjiajie Folk Culture Activity Month kicked off in Zhangjiajie Tusi City. It has been successfully held for 3 sessions.

中国·张家界国际旅游诗歌节

Zhangjiajie International Tourism Poetry Festival, China

自2017年举办以来，已连续举办5届。诗歌节以诗为媒、以诗会友、以诗传情，尽展张家界诗意山水。

It has been held for five consecutive sessions since 2017. The Poetry Festival uses poetry as a medium where people make friends and exchange feelings with poetry, which thoroughly shows the poetic mountains and water of Zhangjiajie.

中国 · 张家界首届世界遗产摄影大展

The First World Heritage Photography Exhibition in Zhangjiajie, China

2020 年 11 月 16 日至 22 日，中国 · 张家界首届世界遗产摄影大展在张家界市举行，把张家界的山水、自然、文化之美，更多、更全面、更精彩地呈现给全世界。

From November 16 to 22, 2020, the first World Heritage Photography Exhibition of Zhangjiajie was held in Zhangjiajie city, presenting the landscape, natural and cultural beauty of Zhangjiajie in a more comprehensive and wonderful way to the world.

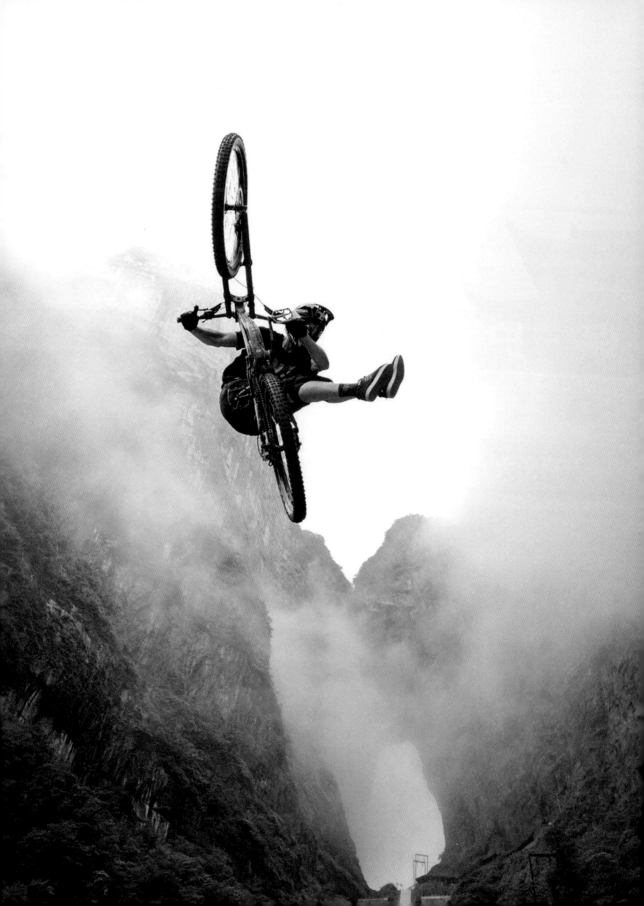

去成为风，畅享自由。
感受山水自然的别趣，
和云朵的呼吸同频。
去成为阳光，尽情发光。
挥洒青春激扬的汗水，
与大地的心跳共振。
去玩，去疯，去野，
去这片大地恣意畅爽，
揣着快乐满载而归。

To be the wind, to enjoy the freedom.
Feel the interests of the natural landscapes in the same
frequency with of cloud's breath.
To be the sun, to shine brightly.
Asperse inspiring sweat in resonance with the earth's
heartbeat.
To play, to go crazy, to go wild.
To meander arbitrarily in this land, back with full of
happiness.

山城趣游

Funny Tour in

Mountain city

激情体育
Passion for Sports

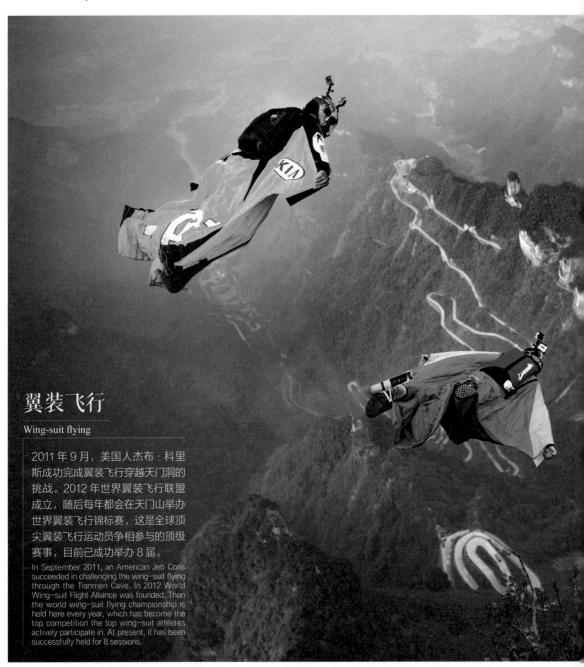

翼装飞行
Wing-suit flying

2011 年 9 月，美国人杰布·科里斯成功完成翼装飞行穿越天门洞的挑战。2012 年世界翼装飞行联盟成立，随后每年都会在天门山举办世界翼装飞行锦标赛，这是全球顶尖翼装飞行运动员争相参与的顶级赛事，目前已成功举办 8 届。

In September 2011, an American Jeb Coris succeeded in challenging the wing-suit flying through the Tianmen Cave. In 2012 World Wing-suit Flight Alliance was founded. Then the world wing-suit flying championship is held here every year, which has become the top competition the top wing-suit athletes actively participate in. At present, it has been successfully held for 8 sessions.

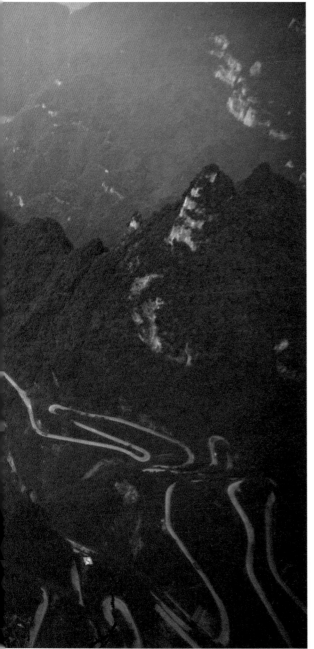

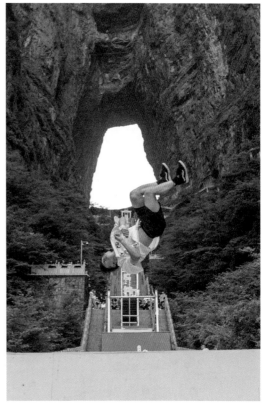

"云纵天梯" 跑酷

"Cloud Ladder" Parkour

2022 年 7 月 23 日至 24 日，天门山 "云纵天梯" 跑酷大赛在天门山景区举行。本次比赛是近几年国内技术难度最大、场地环境最为独特的跑酷大赛。

From July 23 to 24, 2022, the "Cloud Ladder" Parkour Competition was held in Tianmen Mountain Scenic Area. It is the most technologically difficult, the most unique environment parkour competition with the most unique environment in recent years.

高空走扁带

High-altitude Walking on the Flat Belt

2018年5月27日和12月23日，张家界天门山和黄石寨先后进行了高空走扁带极限挑战，多名中外扁带运动高手轮番上演"空中漫步"，目前已成功举办6届。

On May 27 and December 23, 2018, Zhangjiajie successively carried out the extreme challenge of high-altitude walking on the flat belt in Tianmen Mountain and Huangshi Village. A number of Chinese and foreign flat-belt sports masters staged "air walk". At present, it has been successfully held for 6 sessions.

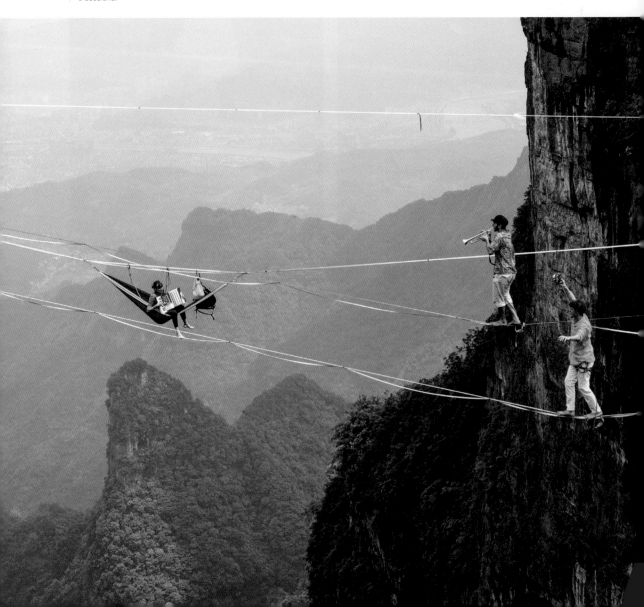

峰林骑行

Peak Forest Cycling

张家界武陵源"峰林骑行"自行车穿越赛，选手们在峰林中骑行穿越，体验别样的户外运动魅力，目前已成功举办 10 届。

In Wulingyuan "Peak Forest Cycling" Race，the players ride through the peak forest and experience a different charm of outdoor sports. At present, it has been successfully held for 10 sessions.

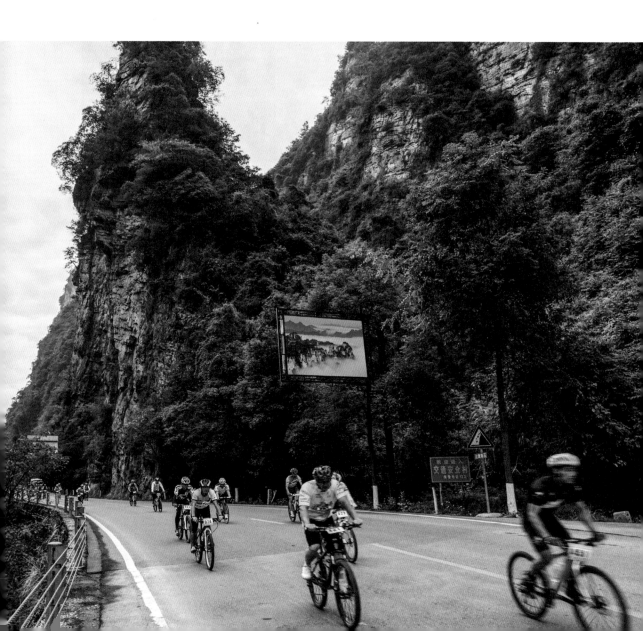

张家界马拉松

Zhangjiajie Marathon

▶ 半程马拉松

Half Marathon

2020 年 11 月 14 日上午，首届张家界半程马拉松在市民广场鸣枪开跑。来自全国各地的 5000 余名选手齐聚张家界，用奔跑的方式感受这座城市的灵动与气韵。

On the morning of November 14, 2020, the first Zhangjiajie Half Marathon opened at the Civic Square. More than 5000 athletes from all over the country gathered in Zhangjiajie and feel the spirit and charm of the city by running.

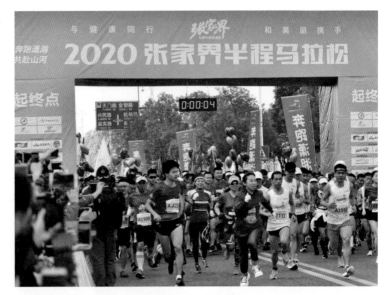

▶ 武陵源生态马拉松

Wulingyuan Ecological Marathon

2021 年 11 月 20 日，张家界武陵源生态马拉松在标志门广场开跑。广大跑友在激情畅跑的同时，还能欣赏奇峰三千、秀水八百的武陵源美景，目前已成功举办 2 届。

On November 20,2021, Wulingyuan Ecological Marathon in Zhangjiajie started at the Sign-Gate Plaza. While the players ran in passion, they could enjoy the magic peaks and beautiful water of Wulingyuan beautiful scenery. At present, it has been successfully held for 2 sessions.

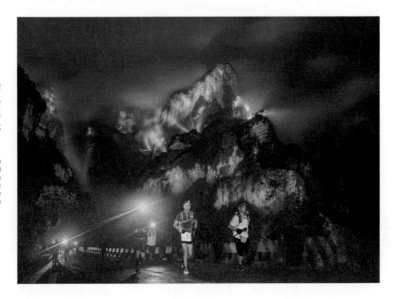

大峡谷蹦极
Grand Canyon Bungee

勇敢者的游戏
The Game of the Brave

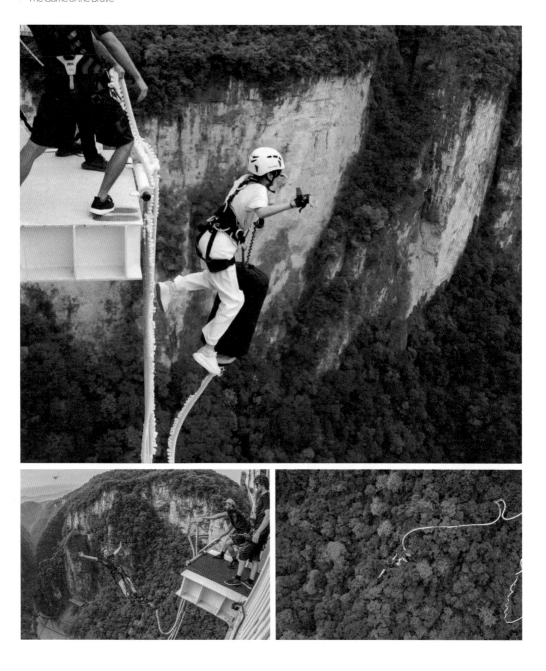

大峡谷飞拉达

Grand Canyon Via Ferrata

飞檐走壁赏奇山
Climbing mountains and appreciating the beauty of nature

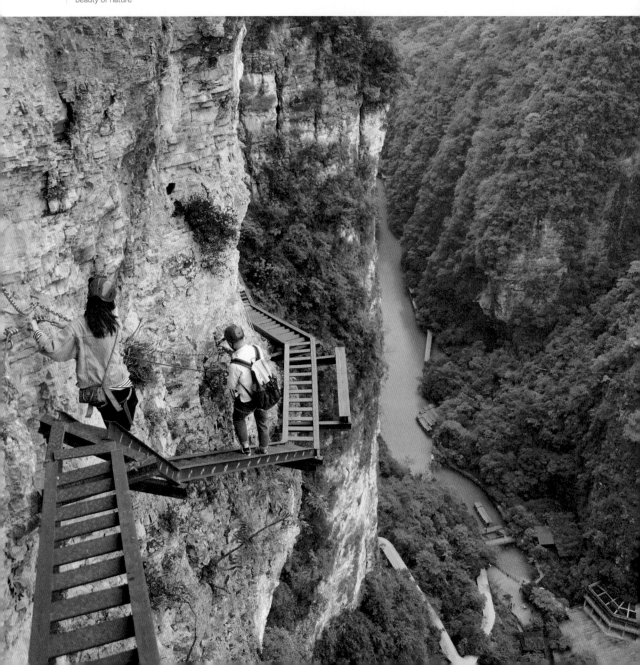

大峡谷高空滑索

Grand Canyon High-altitude Ropeway sliding

换个角度看世界
Look at the world from another perspective

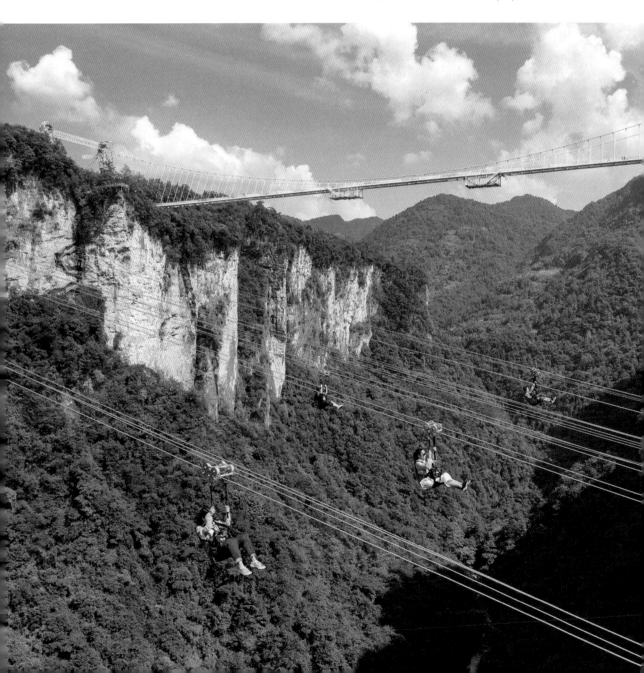

七星山直升机低空飞行
Low altitude flight of Helicopter on Seven-star Mountain

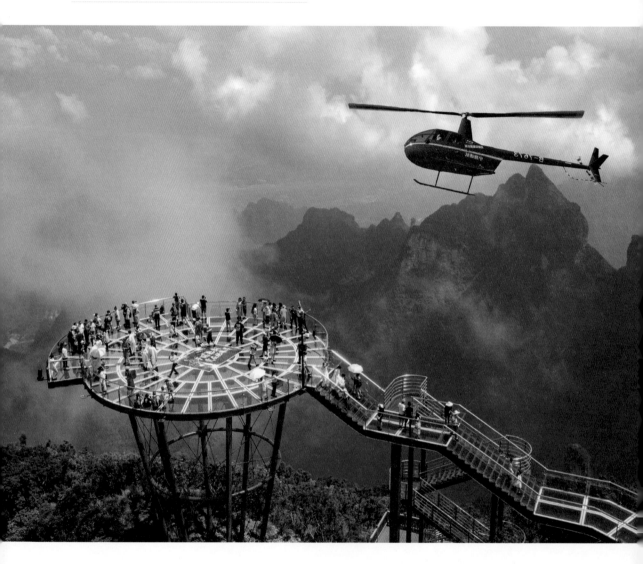

茅岩河快艇

Maoyan River Yacht

体验急速带来的刺激
Experience the stimulation
brought by the rapid-speed
movement

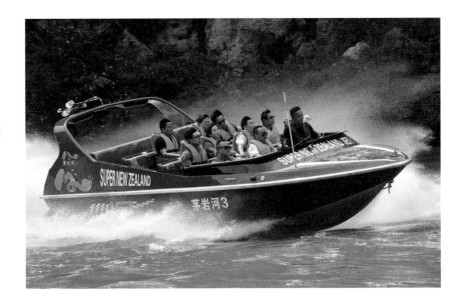

茅岩河漂流

Maoyan River Drifting

流动的山水画
Moving landscape painting

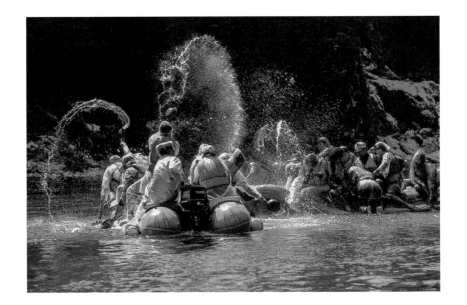

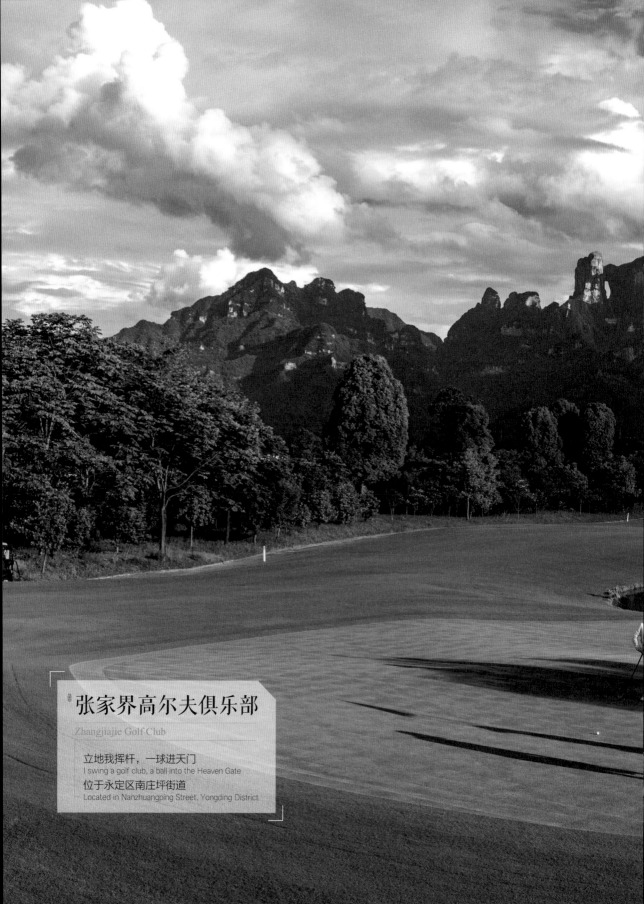

张家界高尔夫俱乐部
Zhangjiajie Golf Club

立地我挥杆，一球进天门
I swing a golf club, a ball into the Heaven Gate
位于永定区南庄坪街道
Located in Nanzhuangping Street, Yongding District

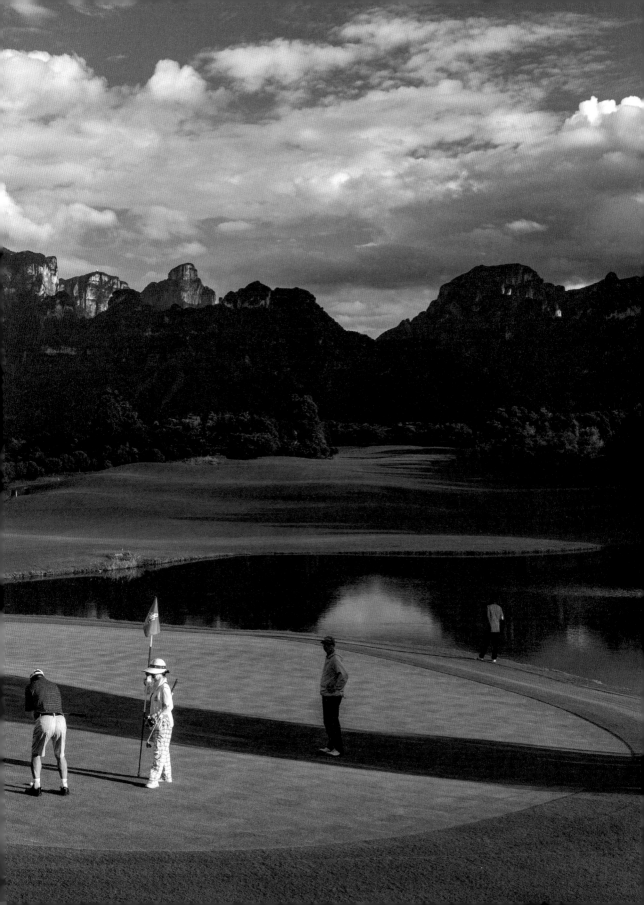

张家界冰雪世界

Zhangjiajie Ice and Snow World

梦幻冰雪世界
— Dream ice and snow world
位于慈利县阳和土家族乡
— Located in Yanghe Tujia Township, Cili
County

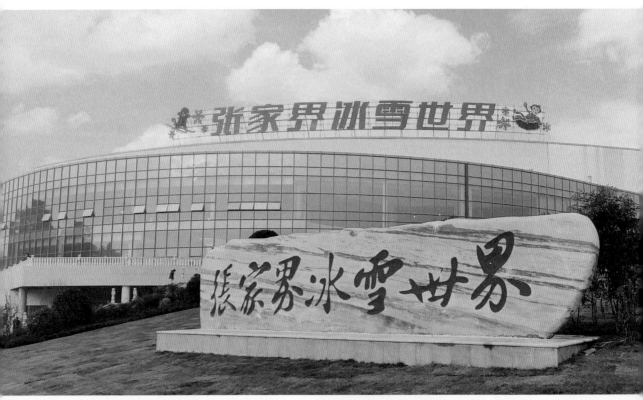

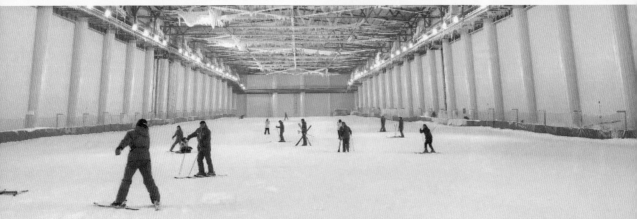

悬崖花开 1 号营地

Cliff Flower No. 1 Camp

体验越野之狂美，享受星空之静谧
Experience the wilderness beauty, enjoy the
silence of the starry sky

位于慈利县三官寺土家族乡
Located in Sanguan Temple, Tujia Township,
Cili County

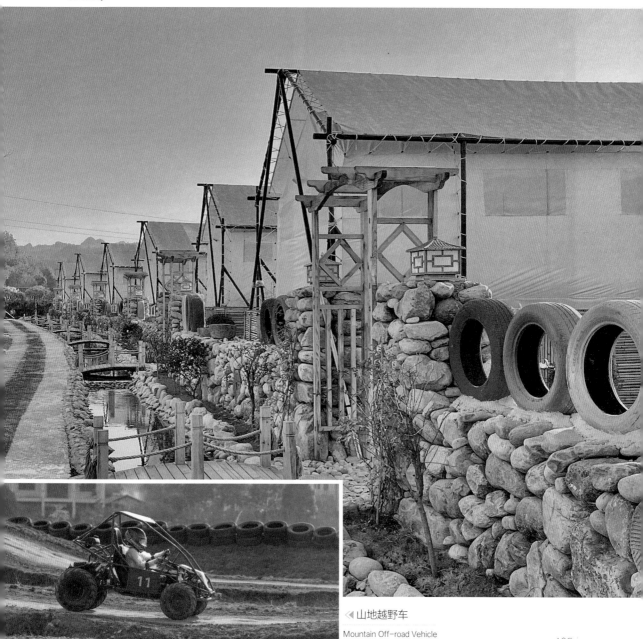

◀ 山地越野车

Mountain Off-road Vehicle

樟树营

Camphor-tree Camp

心跳与浪漫的交融
The blend of heartbeat and romance

位于慈利县溪口镇
Located in Xikou Town, Cili County

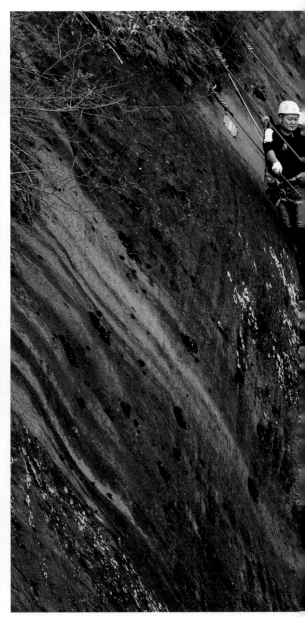

红岩岭

Red Rock Ridge

户外运动新天地
Outdoor sports new world
位于慈利县甘堰土家族乡
Located in Ganyan Tujia Township, Cili County

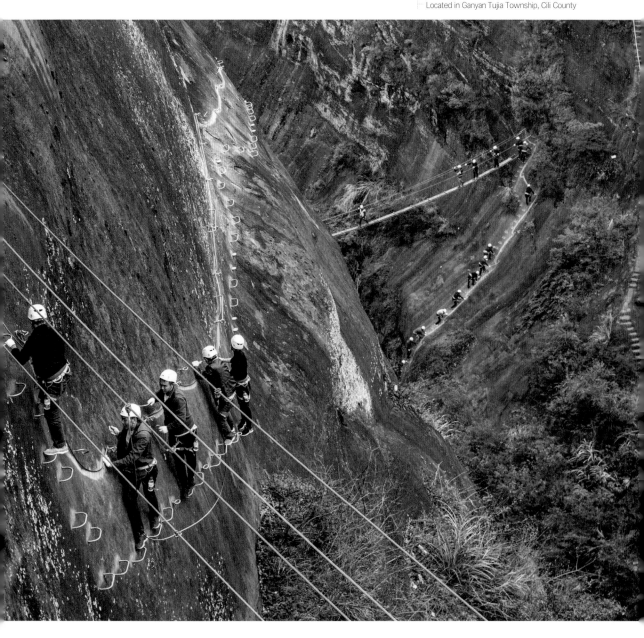

快乐研学
Happy Study

张家界市博物馆
Zhangjiajie Museum

湖南省爱国主义教育基地
Hunan Patriotism Education Base

揭秘古今张家界
Uncovering Ancient and Modern Zhangjiajie

位于永定区大庸桥街道
Located in Dayong Bridge Street, Yongding District

张家界世界地质公园博物馆

Zhangjiajie World Geopark Museum

驻足一刻，穿越亿年
One moment here, is like several hundred million years of time

位于武陵源区水绕四门
Located in Four Mingling Streams, Wulingyuan District

世界遗产影像馆
World Heritage Image Museum

一览世界遗产的风采
A Glimpse of World Heritage

位于永定区大庸古城
Located in Ancient Dayong City, Yongding District

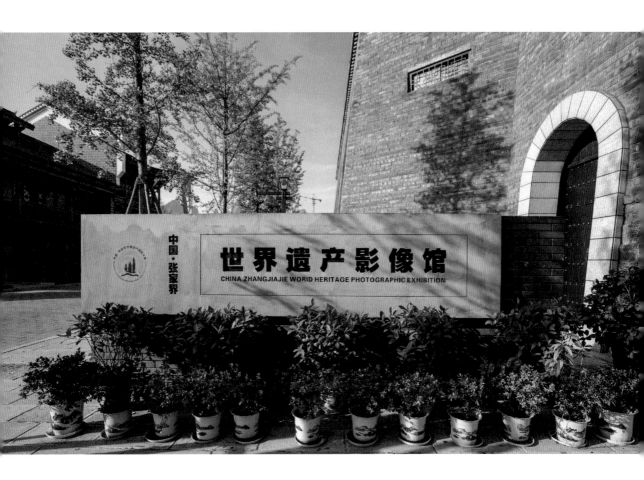

中国大鲵生物科技馆

Chinese Giant Salamander Biotechnology Museum

馆藏大鲵亿万年
Giant salamander collection of billions of years
位于武陵源区军地坪街道
Located in Jundiping Street, Wulingyuan District

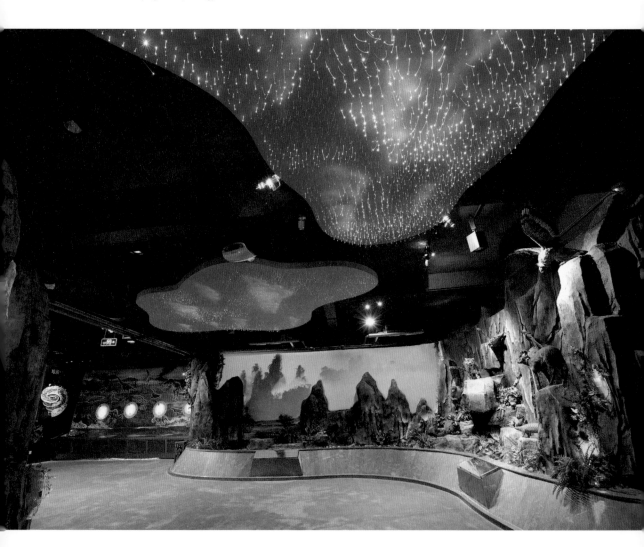

军声砂石画文创园

Junsheng Sandstone-painting Cultural
Creativity Park

与自然山水风光交相辉映
Blending with natural landscapes

位于永定区旅游商品产业园
Located in Tourism Industrial Park, Yongding
District

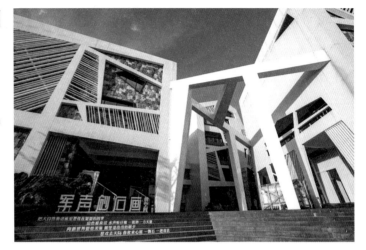

荷堂艺术馆

Hetang Art Museum

半顷荷塘里的艺术精品
Fine artistic works of half a hectare of lotus
pond

位于永定区南庄坪街道
Located in Nanzhuangping Street, Yongding
District

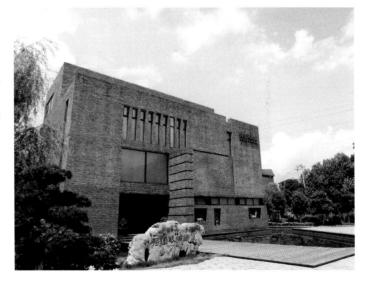

怡然体验
Comfortable Experience

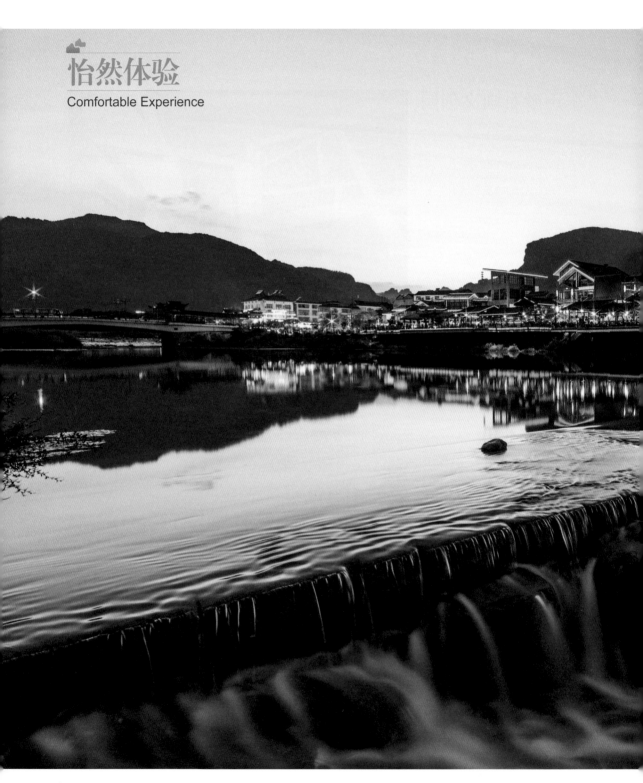

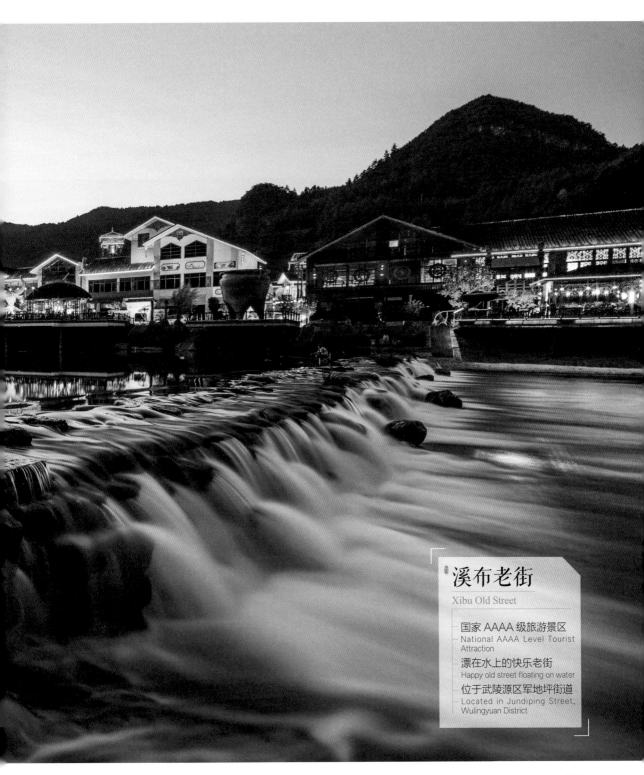

溪布老街

Xibu Old Street

- 国家 AAAA 级旅游景区
 National AAAA Level Tourist Attraction
- 漂在水上的快乐老街
 Happy old street floating on water
- 位于武陵源区军地坪街道
 Located in Jundiping Street, Wulingyuan District

大庸古城
Ancient Dayong City

张家界城市发展的源头
— The source of Zhangjiajie's urban development
张家界人难忘的城市印记与情怀
— Zhangjiajie's people's unforgettable city imprint
and feelingings
位于永定区崇文街道
— Located in Chongwen Street, Yongding District

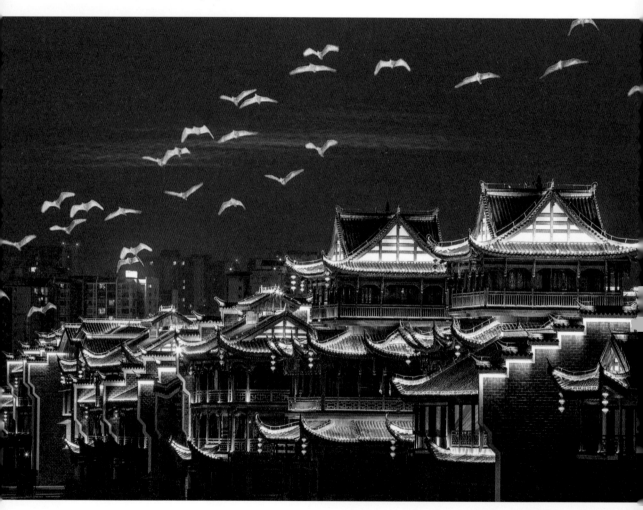

七十二奇楼

The 72 Magic Buildings

张家界首个夜生活艺术小镇
The First Nightlife Art Town in Zhangjiajie

位于永定区大庸桥街道
Located in Dayong Bridge Street, Yongding District

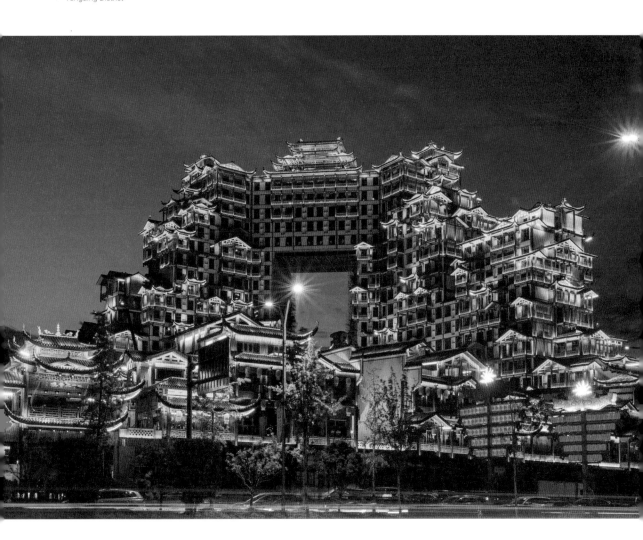

琵琶洲

Pipa Island

三季有花、四季有景，花开满园、移步异景
There are flowers in three seasons, different styles of scenery in four seasons. Flowers bloom in the garden, and the scenery is different from step to step.

国家 AAA 级旅游景区
National AAA Level Tourist Attraction

位于慈利县零阳街道
Located in Lingyang Street, Cili County

马儿山

Ma'er Mount Village

灵山秀色，温泉氤氲
Beautiful scenery and cozy hot spring
位于永定区尹家溪镇
Located in Yinjiaxi Town, Yongding District

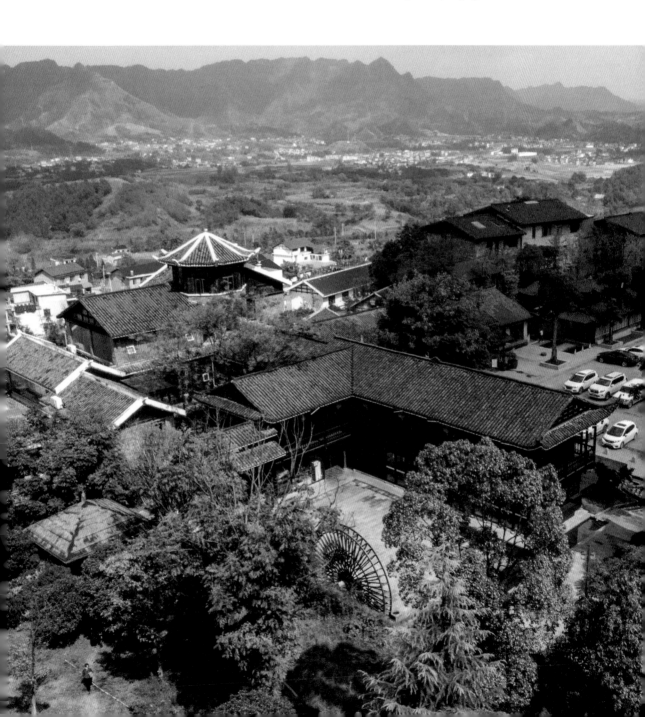

柳叶溪

Willow Leaf Stream

画里乡村、古寨风韵
Painting Village, Ancient Charm

位于永定区天门山镇
Located in Tianmen Mount Town, Yongding District

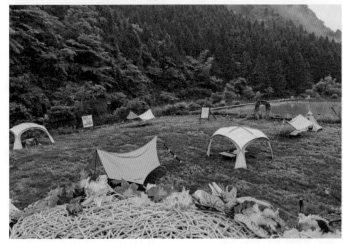

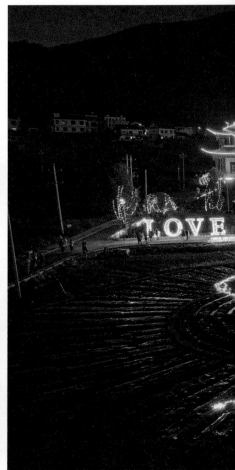

桑植民歌寨
Sangzhi Folk Song Village

风景如画，歌声悠扬
Picturesque scenery, melodious songs

位于桑植县空壳树乡
Located in Kongke Tree Township, Sangzhi County

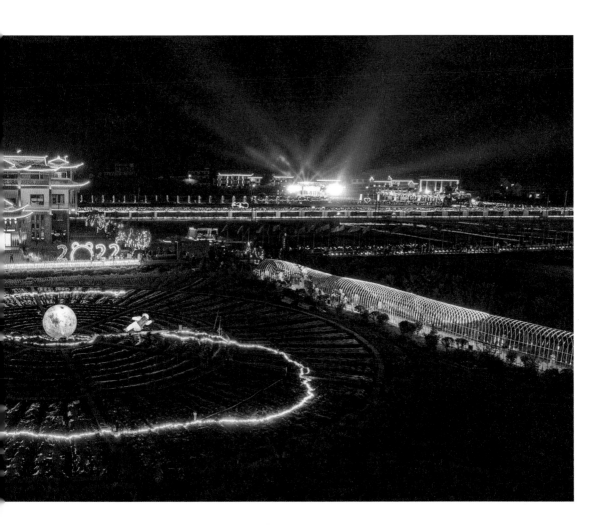

江垭温泉

Jiangya Hot Spring

仿古式半露天温泉
Archaized Semi-outdoor Spa

国家 AAAA 级旅游景区
National AAAA Level Tourist Attraction

位于慈利县江垭镇
Located in Jiangya Town, Cili County

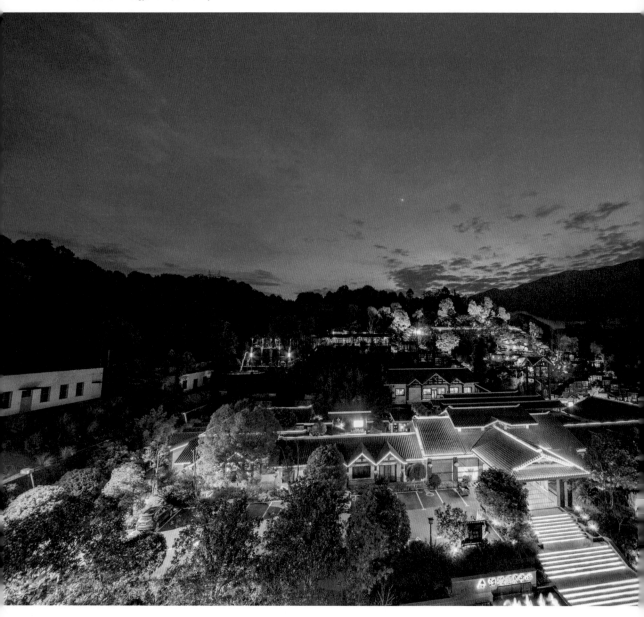

万福温泉

Wanfu Hot Spring

福文化主题温泉
Fu Culture Theme Spa

国家 AAAA 级旅游景区
National AAAA Level Tourist Attraction

位于慈利县长张高速公路慈利东互通处
Located at Cili East interchange, Changsha–Zhangjiajie Expressway, Cili County

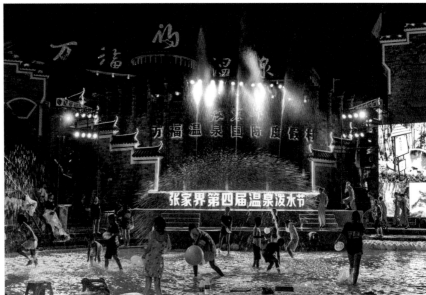

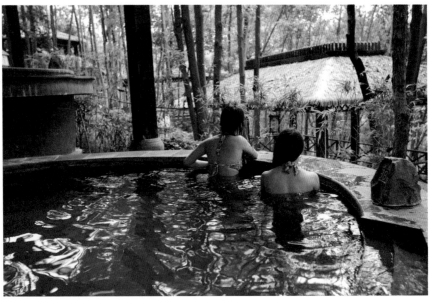

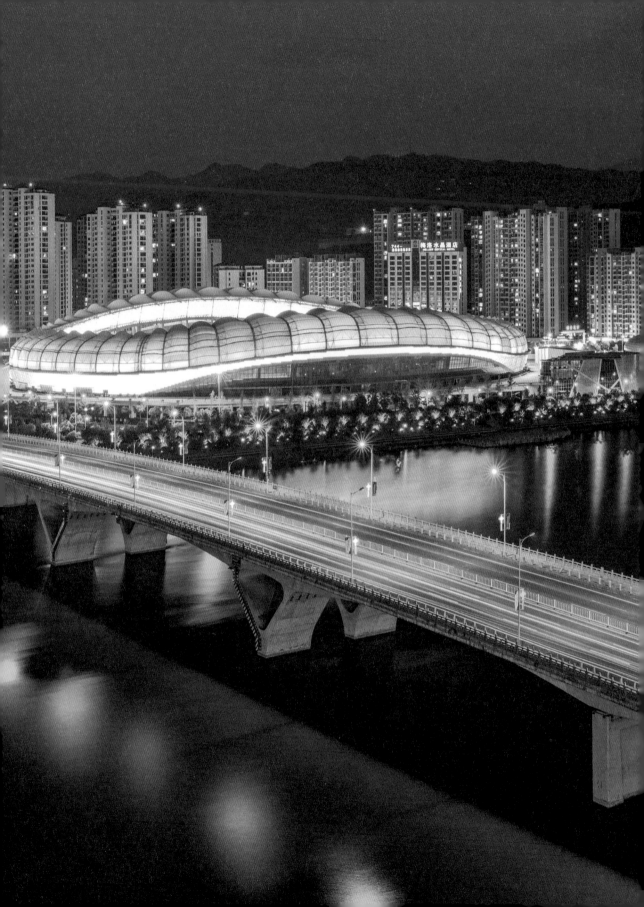

走吧，丢下所有的倦怠和烦恼。

走吧，抛开所有的沮丧和忧愁。

走吧，去寻找心灵的家园。

走吧，向着自由出发。

走吧，去那遗落人间却胜似仙境的地方。

带上快乐，揣着期待，

仙境张家界在等你。

Go, and leave all the burnout and annoyance.

Go, and put aside all the frustration and sorrow.

Go, and find the home of the heart.

Go, and start toward freedom.

Go, and go to the place where the world is better than a fairyland.

With happiness and expectation, Wonderland Zhangjiajie is waiting for you.

畅游心选

Enjoyable
Tour to Scenic Spots

悦享美味
Delicious Cuisine

张家界十大名菜
Zhangjiajie Top ten Famous Dishes

▶▶1. 土家扣肉
· Tujia Steamed Pork

▶▶2. 妈妈炒肉
· Mother's Fried Meat

▶▶3. 黄焖娃娃鱼
· Braised Giant Salamander

▶▶4. 招牌红烧桂鱼
· Signature Braised Cinnamon Fish

▶▶5. 稻香红烧肉
· Rice Fragrant Braised Pork in Soy Sauce

▶▶6. 干锅鸭丝
· Dry Pot Shredded Duck

▶▶7. 腊猪脚鼎罐鸡
· Preserved Trotters with Jarred Chicken

▶▶8. 白石黑山猪
· Baishi Black Mountain Pork

▶▶9. 溪口牛肉
· Xikou Beef

▶▶10. 岩耳炖土鸡
· Stewed Native Chicken with Rock Fungus

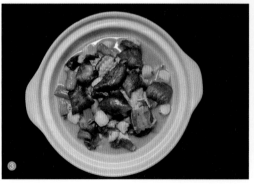

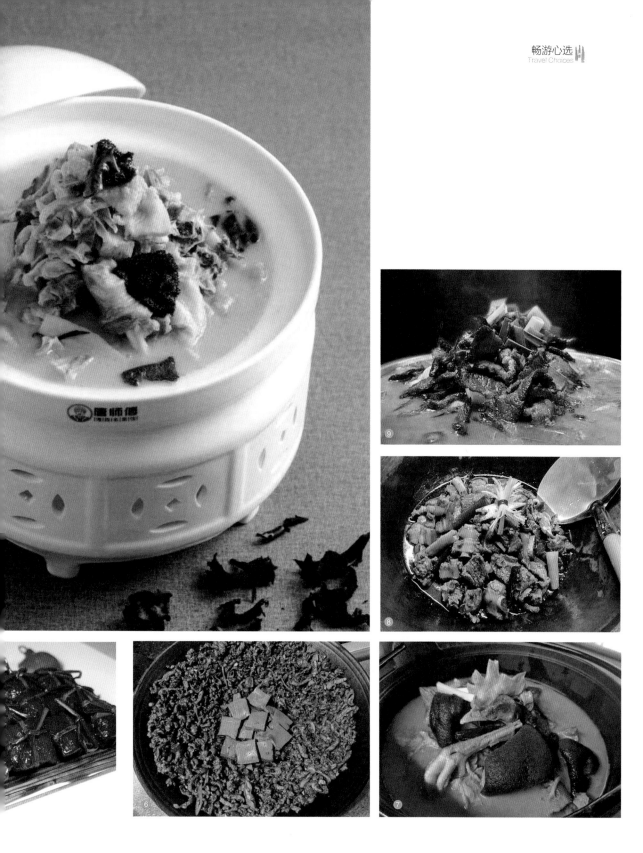

张家界十大小吃

Zhangjiajie Top Ten Snacks

▶▶ 1. 蒿子粑粑
· Wormwood Baba

▶▶ 2. 土家合渣
· Tujia Soybean Dregs with Greens

▶▶ 3. 麦汤馂
· Wheat-meal Ball Soup

▶▶ 4. 刘家坪饺子
· Liujiaping Dumplings

▶▶ 5. 熊氏草帽面
· Xiong's Straw-hat Noodles

▶▶ 6. 茶油酥饼
· Tea Oil Crispy Cake

▶▶ 7. 强哥凉面
· Brother Qiang's Cold Noodles with Sesame Sauce

▶▶ 8. 葛根粉
· Kudzu Root Powder

▶▶ 9. 凉水口油粑粑
· Liangshuikou Pie with Rice and Soybean

▶▶ 10. 鸭肉粉
· Duck Rice Noodles

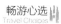

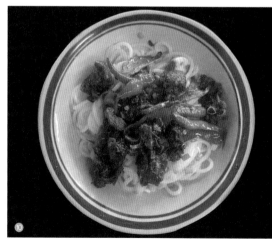

张家界十大餐饮名店

Zhangjiajie Top Ten Restaurants

▷ 1. 秦大妈·晚香（新外滩店）

📍 永定区鹭鸶湾大桥北侧东岳·新外滩旁

📞 0744-8286969

- Aunt Qin's Wanxiang·Night Fragrance（New Bund Restaurant）
- Address: Dongyue, North side of Egret Bay Bridge, Yongding District, beside New Bund
- Telephone: 0744-8286969

▷ 2. 乌龙山寨（江与城店）

📍 永定区官黎坪街道澧兰中路江与城一期 S08 铺

📞 0744-8283148

- Wulong Village（River & City Restaurant）
 Address: Shop S08 of River& City Phase 1, Lilan Middle Road, Guanliping Street,Yongding District
- Telephone: 0744-8283148

▷ 3. 乐口福家常菜馆

📍 永定区古庸路张家界市人民医院斜对面

📞 0744-2199788

- Lekoufu Home-style Cooking Restaurant
- Address: Catty-corner across Zhangjiajie People's Hospital, Guyong Road, Yongding District
- Telephone: 0744-2199788

▷ 4. 溪涧小院

📍 永定区邢家巷大桥下薄利购物中心对面

📞 0744-8587777

- Xijian Courtyard
- Address: Opposite to Boli Shopping Center, Under Xingjiaxiang Bridge, Yongding District
- Telephone: 0744-8587777

▷ 5. 索溪山寨·湘西民间土菜（溪布街店）

📍 武陵源区天子路宝峰桥头溪布街入口

📞 0744-5956666

- Suoxi Village Xiangxi Folk Dishes（Xibu Street Restaurant）
- Address: Entrance to Xibu Street, Baofeng Bridgehead, Tianzi Road, Wulingyuan District
- Telephone: 0744-5956666

▷ 6. 蓝湾博格国际酒店

📍 永定区南庄坪街道天崇路与荷花路交汇处蓝色港湾小区旁

📞 0744-8837777

- Blue Bay Hotel
- Address: Beside Blue Bay Apartment Complex at the intersection of Tianchong Road and Lotus Road, Nanzhuangping Street, Yongding District
- Telephone: 0744-8837777

▷ 7. 湘府国际温泉酒店

📍 武陵源区军邸路与桂花路交叉口

📞 0744-2881888

- Xiangfu International Hot Spring Hotel
- Address: At the intersection of Jundi Road and Guihua Road, Wulingyuan District
- Telephone: 0744-2881888

▷ 8. 银满斗火锅店（步行街总店）

📍 永定区回龙路东门巷 22 号

📞 0744-2161358

- Yinmandou Hotpot Restaurant（Head Restaurant in Pedestrian Street）
- Address: Number 22, East Gate Lane, Huilong Road, Yongding District
- Telephone: 0744-2161358

▷ 9. 唐师傅湘西名菜馆

📍 武陵源区武陵大道亘立酒店对面

📞 0744-5557776

- Tang Master Xiangxi Famous Dishes Restaurant
- Address: Opposite to Genli Hotel, Wuling Avenue, Wulingyuan District
- Telephone: 0744-5557776

▷ 10. 桂香圆农家乐

📍 桑植县澧源镇建兴岭社区

📞 0744-2222555

- Guixiangyuan Agritainment
- Address:Jianxingling Community Commttee, Liyuan Town, Sangzhi County
- Telephone:0744-2222555

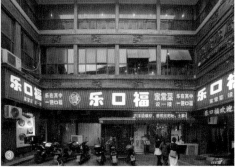

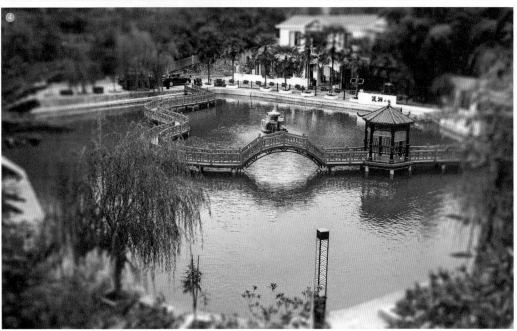

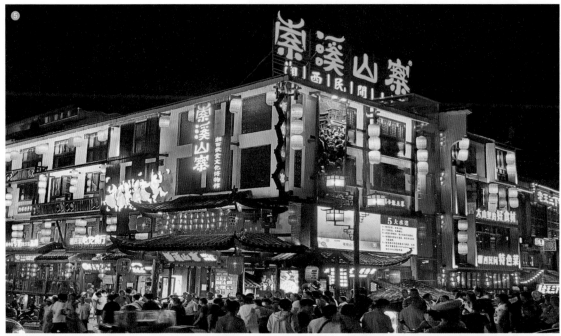

趣享特产
Special Local Products

吉祥物文创产品
Cultural Creative Mascot

▲ 山娃娃
Mountain Doll

▲ 鲵宝宝
Baby Salamander

▲ 手办
Garage Kit

T 恤 ▲
T-shirts

▲ 钥匙扣
Key Ring

▲ 马克杯
Mug

▲ 帆布包
Canvas Bags

▲ 圆形徽章
Round Badges

张家界十大旅游商品
Zhangjiajie Top Ten Tourism Goods

▷▷ 1. 茅岩莓茶
· Maoyan Vine Tea

▷▷ 2. 砂石画
· Sand-stone Paintings

▷▷ 3. 大鲵蛋白肽
· Protein Peptide of Giant Salamanders

▷▷ 4. 葛根饮料
· Kudzu Root Juice

▷▷ 5. 土家织锦
· Tujia Brocade

▷▷ 6. 湘帅印桑植白茶
· Sangzhi White Tea

▷▷ 7. 天门郡莓茶
· Tianmen County Vine Tea

▷▷ 8. 洞溪七姊妹辣椒
· Dongxi Seven Sisters Hot Pepper

▷▷ 9. 青钱柳茶
· Qingqianliu tea

▷▷ 10. 土家风味麦酱
· Tujia Flavor Wheat Paste

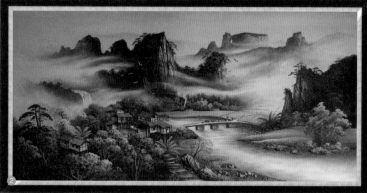

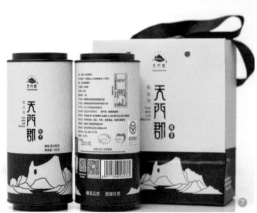

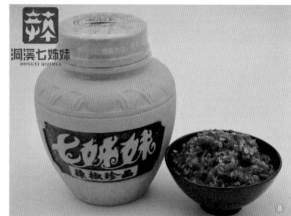

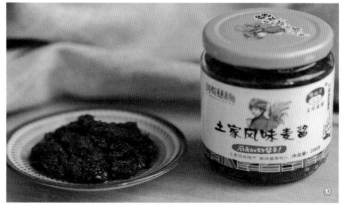

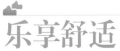
乐享舒适
Comfortable Accommodation

阳光酒店
Sunshine Hotel

位于永定区西溪坪街道
Located in Xixiping Street,Yongding District

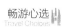
京武铂尔曼酒店

Jingwu Pullman Hotel

位于武陵源区军地坪街道
Located in Jundiping Street, Wulingyuan
District

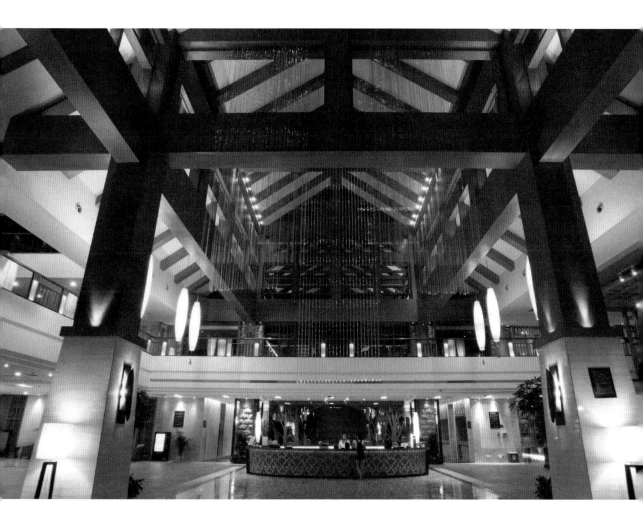

青和锦江国际酒店

Qinghe Jinjiang International Hotel

位于武陵源区军地坪街道
Located in Jundiping Street, Wulingyuan
District

华天大酒店

Huatian Hotel

位于永定区官黎坪街道
Located in Guanliping Street, Yongding
District

碧桂园凤凰酒店

Country Garden Phoenix Hotel

位于永定区大庸桥街道
Located in Dayong Bridge Street,
Yongding District

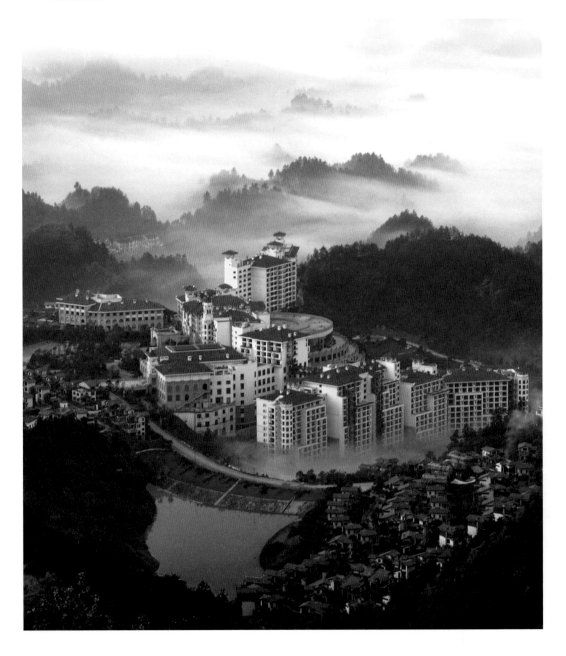

纳百利皇冠假日酒店

Crowne Plaza Zhangjiajie Wulingyuan

位于武陵源区军地坪街道
Located in Jundiping Street, Wulingyuan District

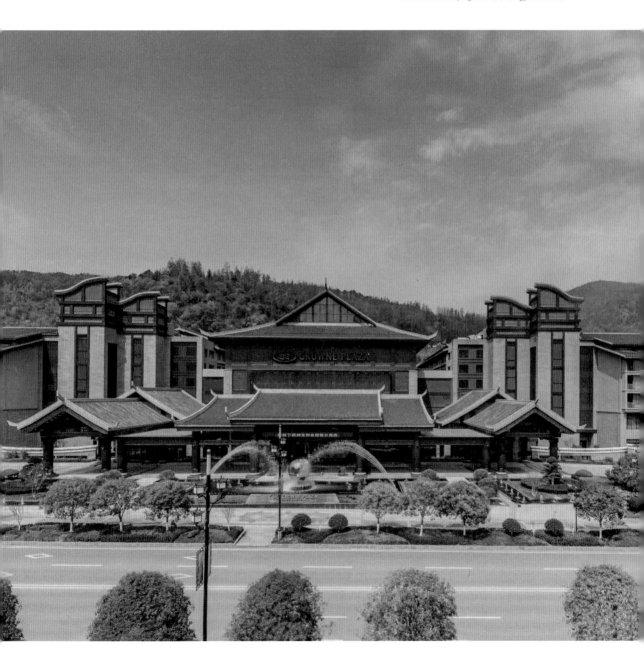

141

张家界禾田居度假酒店

Harmona Resort & Spa Zhangjiajie

位于慈利县三官寺土家族乡
Located in Sanguan Temple, Tujia
Township, Cili County

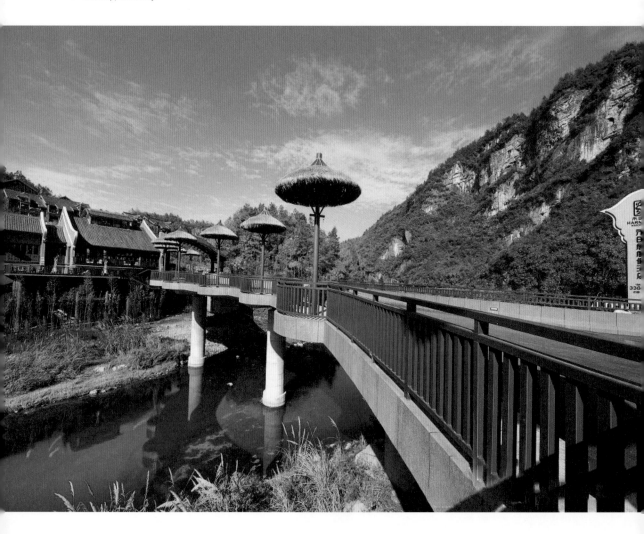

张家界国际大酒店

Zhangjiajie International Hotel

位于永定区大庸桥街道
Located in Dayong Bridge Street, Yongding
District

希尔顿欢朋酒店

Hampton by Hilton

位于永定区官黎坪街道
Located in Guanliping Street, Yongding
District

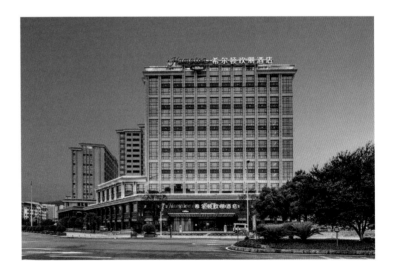

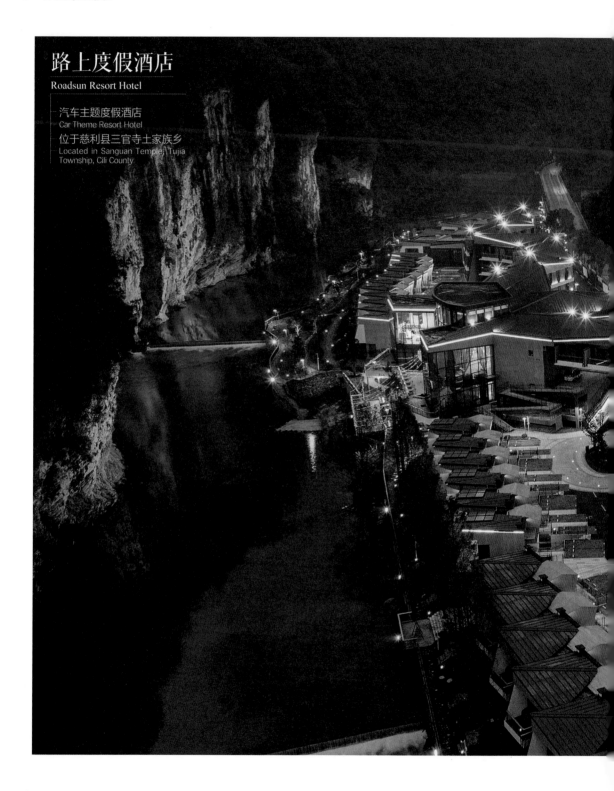

路上度假酒店
Roadsun Resort Hotel

汽车主题度假酒店
Car Theme Resort Hotel
位于慈利县三官寺土家族乡
Located in Sanguan Temple, Tujia
Township, Cili County

五号山谷

No.5 Valley

— 心灵的桃花源
— The Peach Blossom Land of Soul
— 位于武陵源区中湖乡
— Located in Zhonghu Township,
 Wulingyuan District

回家的孩子

The Children Going Home

— 自然的深情呼唤
— Affectionate call from Nature
— 位于武陵源区中湖乡
— Located in Zhonghu Township, Wulingyuan District

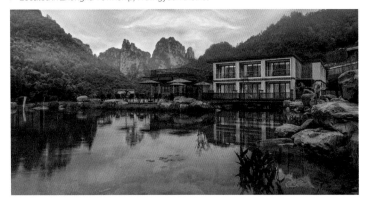

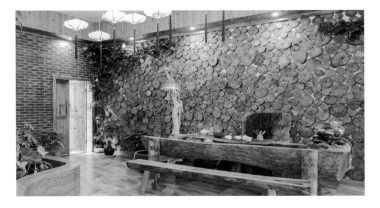

古韵溪

Guyunxi Homestay

— 澧水半岛，古韵犹存
— Li River Peninsula, lasting ancient charm
— 位于慈利县溪口镇
— Located in Xikou Town, Cili County

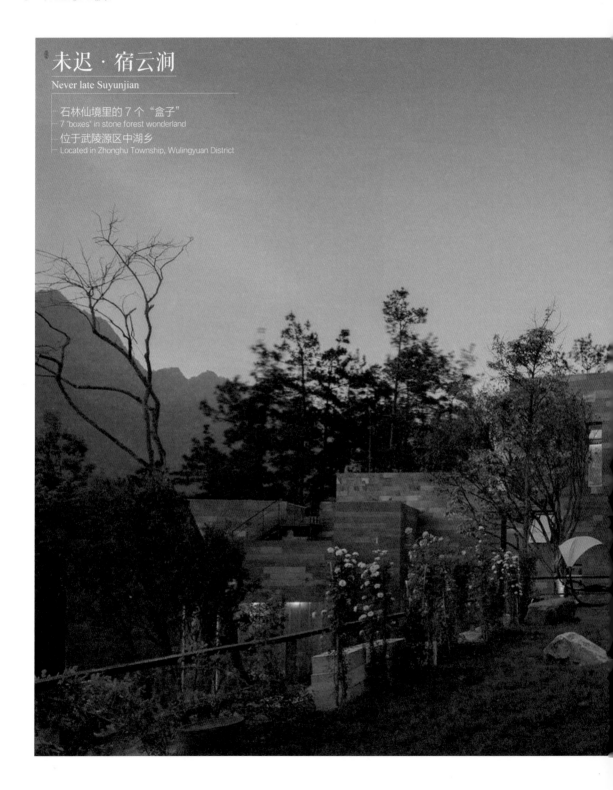

未迟 · 宿云涧

Never late Suyunjian

— 石林仙境里的 7 个 "盒子"
— 7 "boxes" in stone forest wonderland
— 位于武陵源区中湖乡
— Located in Zhonghu Township, Wulingyuan District

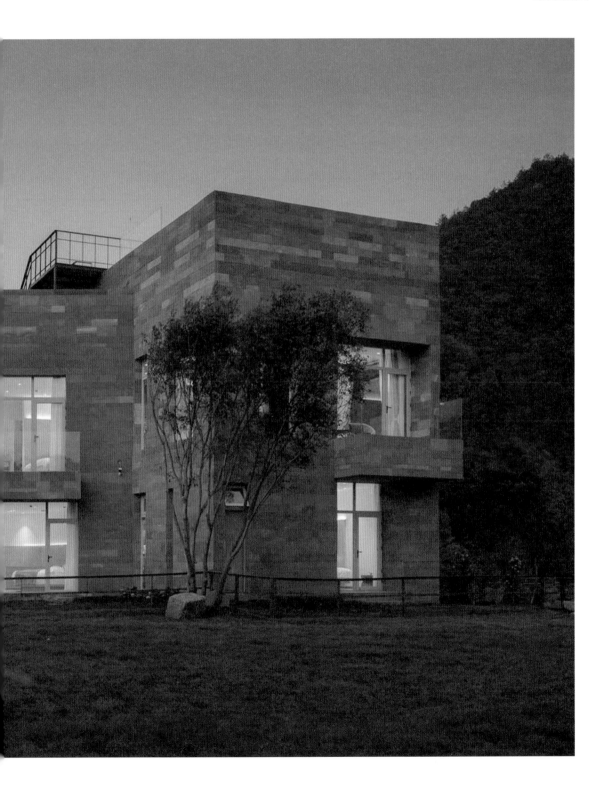

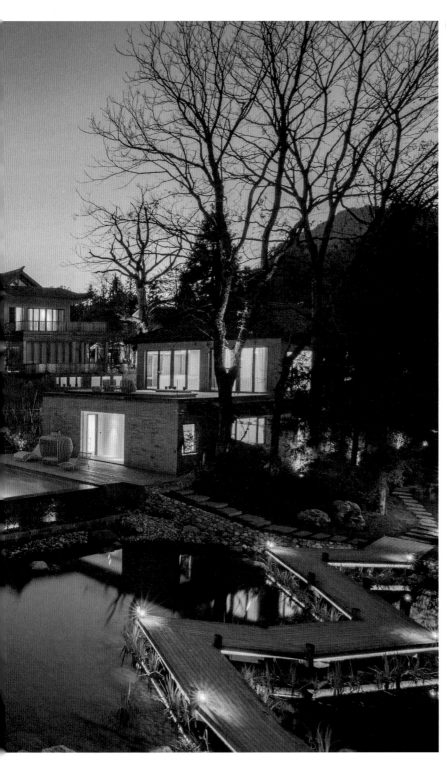

梓山漫居

Catalpa Eco Resort

山谷间的秘密花园
A secret garden in the valley

《时光音乐会》拍摄地
A filming Place of *Time Concert*

位于武陵源区协合乡
Located in Xiehe Township,
Wulingyuan District

远方的家
Distant Home

农耕文化"博物馆"
Farming Culture "Museum"
位于永定区尹家溪镇
Located in Yinjiaxi Town,
Yongding District

大庸秘境
Dayong Mystery

置身于绿野仙踪
Stay in "the Wizard of OZ"
位于武陵源区协合乡
Located in Xiehe Township,
Wulingyuan District

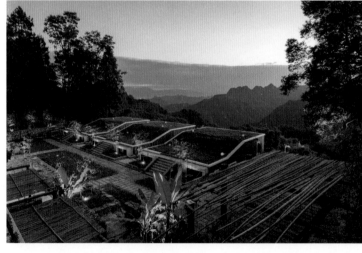

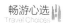
岩语间
Yanyujian Homestay

自然与艺术的对话
A Dialogue between Nature and Art
位于武陵源区协合乡
Located in Xiehe Township, Wulingyuan District

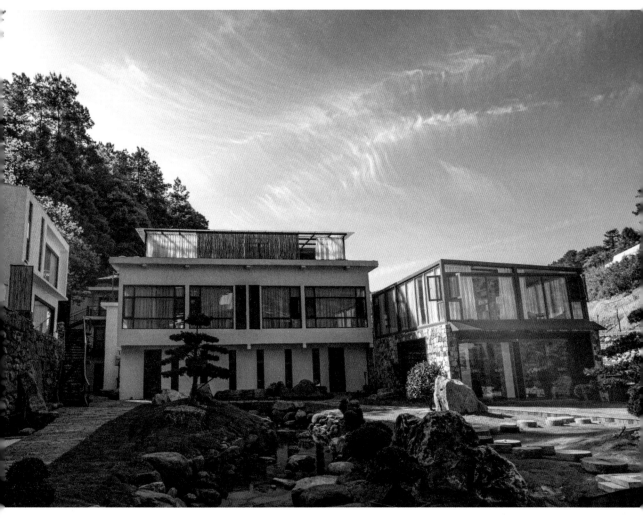

纵享便捷

Convenient Transportation

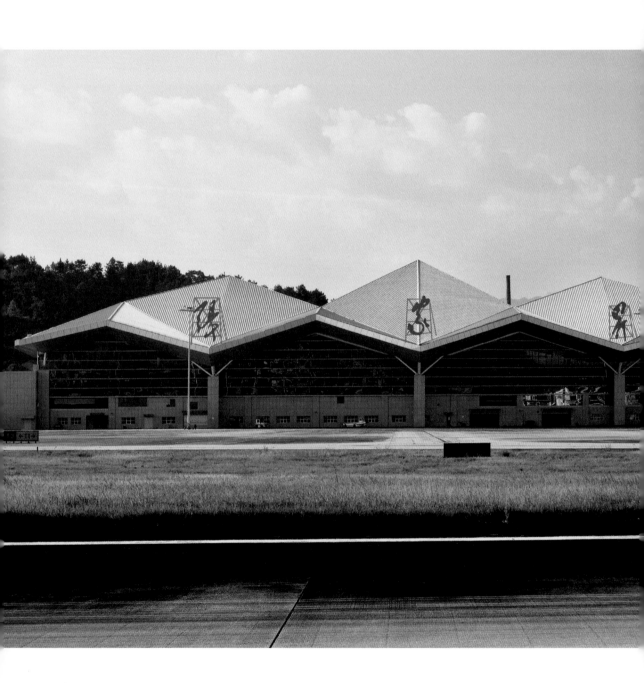

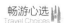
荷花国际机场
Hehua International Airport

位于永定区南庄坪街道
Located in Nanzhuangping Street,
Yongding District

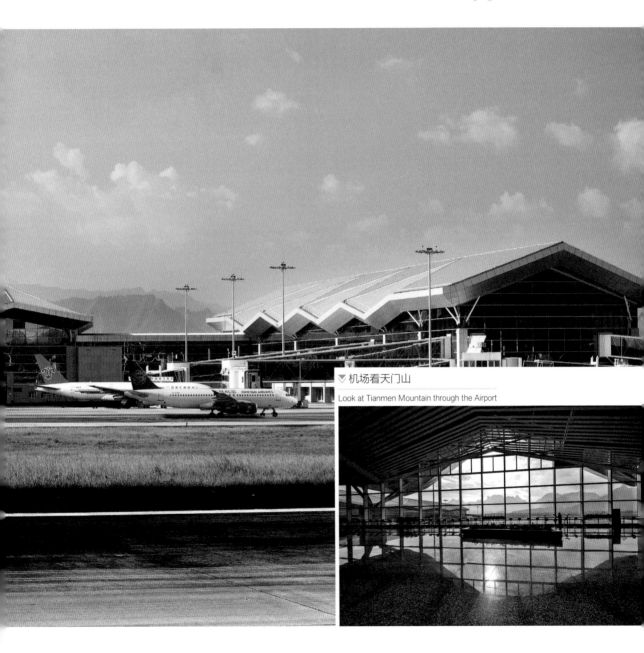

机场看天门山
Look at Tianmen Mountain through the Airport

张家界西站（高铁站）
Zhangjiajiexi Railway Station

位于永定区大庸桥街道
Located in Dayong Bridge Street, Yongding District

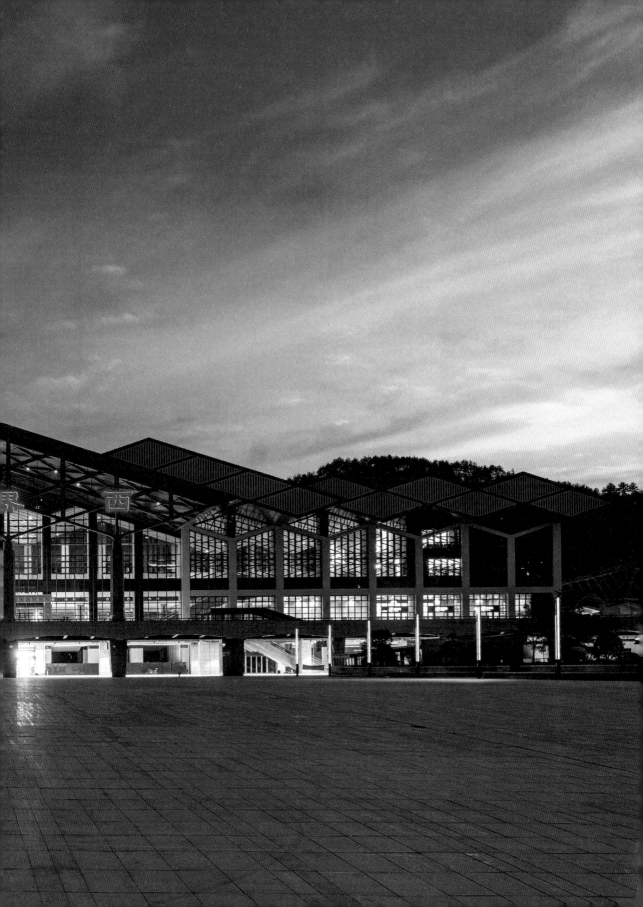

仙境 张家界
WONDERLAND ZHANGJIAJIE

编后记

　　触摸这片神奇土地的脉动，感受自然长河留下的浪花，在为您的旅行提供些许增益之时，编者们也因精力及水平的约束而忐忑不安，或因某些疏漏及不妥而影响张家界的声誉，或因相关旅游信息的滞后而影响您旅行的快乐，虽难免，唯心诚矣，在此致以歉意！本画册部分内容及相关旅游信息收集于2022年之前，如您发现书中有不准确之处，请及时反馈给我们，以便再版时予以更正更新，再次表示感谢！

　　衷心感谢张家界市摄影家协会的支持，本画册才得以将张家界的绝美山水展示在各位读者的面前。

　　书不尽言，愿我们来日相聚于张家界，共赏人间仙境。

Postscript

　　Touch the pulsation of this magical land and feel the waves left by the long river of nature. While providing some benefits for your travel, the editors are also nervous owing to the limitations of energy and level, or afraid to affect Zhangjiajie's reputation due to some omissions and improper expression, or lower your happiness of your travel because of the lag of the related tourism information. Although inevitable, we should sincerely apologize to you. All contents of this album and relevant tourism information are collected before 2022. If you find any inaccuracies in the book, please give us feedback in time so that it can be corrected and updated when republishing. Thank you again!

　　We sincerely thank the Zhangjiajie Photographers Association for their supports that make this album can display the gorgeous scenery of Zhangjiajie to all readers.

　　The book cannot fully deliver my words. I sincerely hope that we can meet in Zhangjiajie and enjoy the wonderland together.